CW00457655

NORTH BRIGHTON
London Road to Coldean
THROUGH TIME
Anthony Beeson

AMBERLEY PUBLISHING

Preston Drove, 1938.

To the Shade of Joan Mavis Beeson (later Claydon)
1917–92
The Best of Aunts
It can't be lost can it? What has been lived and shared is never lost?
Then this is not goodbye, you will always be with us, and we with you.

First published 2014

Amberley Publishing
The Hill, Stroud, Gloucestershire, GL5 4EP
www.amberley-books.com

Copyright © Anthony Beeson, 2014

The right of Anthony Beeson to be identified as the
Author of this work has been asserted in accordance with
the Copyrights, Designs and Patents Act 1988.

ISBN 978 1 4456 2284 2 (print)
ISBN 978 1 4456 2298 9 (ebook)

British Library Cataloguing in Publication Data.
A catalogue record for this book is available from the
British Library.

Typesetting by Amberley Publishing.
Printed in Great Britain.

Introduction

'In Brighton, as elsewhere, the extremes of wealth produce also a corresponding extreme of poverty ... Intermediate between these two populations, is a third, located in the suburbs of the town, along the London-road. The houses are generally of that small, but neat, box-like description, which is to be found in all the outlets of the modern Babylon; and they are probably inhabited by retired tradesmen, the widowed families of deceased clergymen, and such as having seen better days, retire to spots where poverty is not wholly divested of comfort, and an humble exterior is still accompanied by respectability. This to the eye of the passenger, forms a picturesque and inviting portion of Brighton, and a very pleasing variety to the denuded seacoast imagery of the rest of the town.'

Thus Thomas Hood wrote of London Road in the *New Monthly Magazine* of 1841, after arriving in town by the five-hour stagecoach. Soon the railway would engender an astonishing burst of development that would result in a total change for the area around London Road.

Originally called Queen's Road, London Road formed the start of the shortest and most recent route to the capital via Cuckfield. Before the 1790s, travellers had used the Dyke Road via Steyning, the Lewes Road or the Ditchling Road. By 1830, the pleasant valley was favoured by those wishing for a semi-rural, genteel and yet cheaper alternative to living in Brighton proper. Alas, its glory days were relatively short lived, and by 1850 the western fields and pleasure gardens of the Prince's Dairy had succumbed to rows of railway workers' houses. Their proximity ensured social decline, and although some shops had existed in London Road from the 1830s, commercialisation gradually ousted domesticity.

The Dyke Road was bordered by nurseries and farms supplying Brighton with dairy produce and was slow to be developed until the rise of nearby Prestonville. The Lewes Road was also strangely undeveloped until the 1850s. Its great development beyond Preston Barracks from the 1920s was down to the founding of the 'Utopia of Moulsecoomb', originally intended to house Brighton's slum dwellers. The rents proving exorbitant, the council had to advertise nationally for tenants, which rather defeated the object of the exercise.

Considering Brighton's rapid expansion in the railway age and the huge northern developments that spread over Stanford land in the 1870s, it is interesting that even in 1838 Mr Radley Mott was attempting to save downland pathways and common land from enclosures and development. Beyond Round Hill, the Ditchling Road remained countrified until the development of the Stanford estate. By 1903, *The Building News* bemoaned 'Preston's steep hills covered with brick and slate ... they appear incrusted with a covering of stucco and slates, which is certainly not agreeable to the artistic sense. The rural charm of the green hillside has disappeared, and a dark coating of human habitations has taken its place.'

Newspapers provide the incidents and trivialities of everyday life that official histories ignore. Who, for instance, would guess that bears were imported to number 59 Grand Parade in 1838 to be shot on the premises and turned into James Lipscombe's amazing Bear's Grease

pomade, which cured both dandruff and deafness! Stories connect with old pictures such as that of the visit of the Yorks in 1896 (*see page 27*). Within minutes of that photograph being taken, a triumphal arch formed of ladders and bearing twenty firemen collapsed, hospitalising three people. Advertisements for auction sales of property and houses afford many details. One in December 1836 for numbers 86 and 89, Belgrave Terrace, London Road, informs that the 'Two substantially built and very genteel Residences of modern erection and most pleasantly situated ... are approached by a small Garden tastefully arranged with evergreens and enclosed by a dwarf wall and iron palisade.' A detailed description of the houses' layout concludes with the assurance that they afford 'every domestic comfort for a small family of respectability'.

London Road has fascinated me since my teens. My mother did much of the shopping there that the local shops could not supply. Smarter items could be found in Hanningtons, Vokins or Western Road's Plummer Roddis, but London Road was a bustling economic centre supplying most everyday needs, from toys in Bradshaw's to furniture in the Co-op. Its architecture, and the knowledge that many of the buildings were once admired houses, was intriguing. Many buildings were spoiled by the addition of tacked-on bay windows in late Victorian times but, despite its commercialisation, the road succeeds architecturally because it is mostly on a small scale. Banal developments such as the bland façades of Boots and the Co-op supermarket are a warning, and deserving of a retail park. The demolitions and derelictions of New England Hill's railway houses and the years of uncertainty occasioned by traffic schemes (1972's would have demolished the entire Dairy Estate) discouraged investment and encouraged firms to move elsewhere. Eventually, as has happened elsewhere in Britain where commerce has faltered, some of the historic buildings of London Road may once more be restored to housing. Already, the empty Co-op store has been rebuilt to house students and the Open Market redevelopment will include housing in Francis Street. The vast, sometimes canyon-like, remodelling of the New England Quarter has, unfortunately, yet to link successfully to the London Road in any way, either aesthetically or socially.

This volume is arranged geographically as a series of four textual peregrinations exploring the London and the Dyke roads, Lewes Road through Moulsecoomb to Coldean, and the Ditchling Road to Hollingbury. The illustrations come from my collections. In addition, I thank Hazel Smith, Johnny Muxlow and Peter Whitcomb for kindly opening their albums. Edward Muxlow (1908–96), the actual photographer, was a notable Brighton architect, many of whose buildings, such as the handsome houses at the Woodlands, Withdean and at Patcham, still remain. Amateur photographer Leslie Whitcomb (1915–2010) did sterling work in photographing changing Brighton and his son, Peter, has continued this tradition and utilised this archive for the benefit of Brightonians. Thanks also go to David Gollins, Paul Harrington, Shona Milton and Peter John.

Anthony Beeson

Walk 1

'Rural Dwellings Suitable to Persons of Moderate Fortune'

Dreaming of a time in the late 1820s or 1830s when it was practically a country residence, an interesting and once pretty little villa awaits demolition in February 1989. The house stood on the corner of Wood Street and Trafalgar Street and, notwithstanding having had a shop inserted into it, retained many original features including its front door and glazing. The ground floor façade was rusticated with corner pilasters incised with classical motifs at the first floor level. The windows were set into recessed arches topped with curved mouldings. Moulded stucco wreaths decorated the plain area between them. The window above the door was also recessed in a rectangular frame but had a classical header. An almost identical villa by the same unidentified architect once stood on the east side of St Peter's Street. Theobald House rose on Wood Street in 1966 and the pictured modern redevelopment obliterated the rest and neighbouring properties in Trafalgar Street.

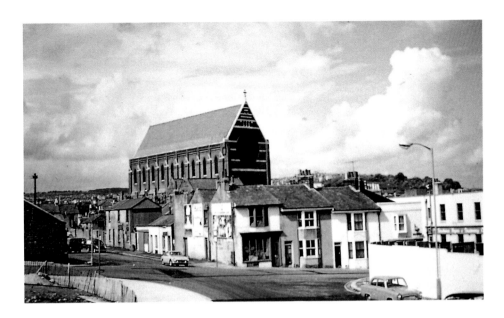

From Cheapside to St Bartholomews, 1968

A photograph taken from the corner of Whitecross Street as the tide of demolition moves towards the small streets and community living between the London Road and the railway works. The southern side of Cheapside had already gone, having been compulsorily purchased by the council in the 1950s at £50 a plot, but elements still survived on the northern side, including well maintained houses and the Queen's Head public house on the corner of Belmont Street to the right. A Watney's Red Barrel sign hangs outside. The building to its right still survives. Opposite Whitecross Street was Fleet Street, now redeveloped into New England Street. Cheapside itself has now been transformed rather remarkably into the A270. Clearances had started as early as the nineteenth century to expand the railway works. When the 1968 photograph was taken, much of the area in view had been served with compulsory purchase orders.

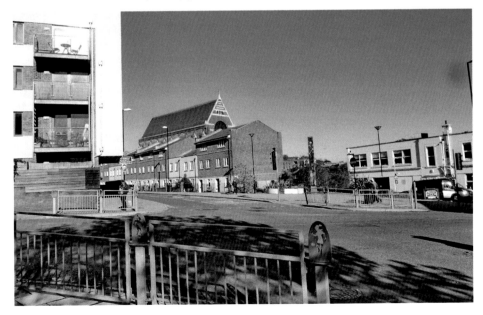

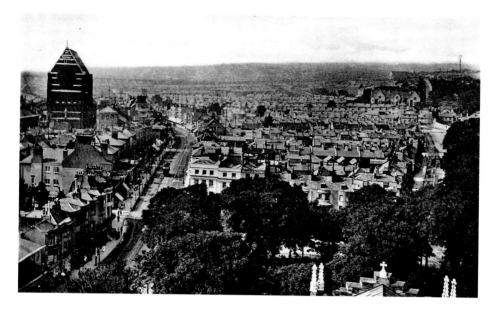

North Brighton from St Peter's Tower, 1912

On the left is London Road; the Co-operative's long sunblind and two identical façades appear at the turn of the road. On the right, Ditchling Road passes the Diocesan Training College and the bosky Rosehill Estate. St Saviour's and the dust destructor's chimney appear beyond. The dense triangular area between the two roads includes some of Brighton's earliest suburban streets. Originally called Prospect Place, the 1820s houses facing the viewer were renamed St Peter's Place after the building of the church. The loss of balconies and canopies and the replacement of gardens with car parks mars them. York Place appears on the left. It includes an interesting 1810s–20s terrace of semi-detached villas, allied to those in London Road (photographed 1992). Although given to commerce and with façades spoiled by Victorian bay windows, two retained their original front doors until recent years. The churchyard was originally planted with twenty species of trees sacred to Christians and pagans.

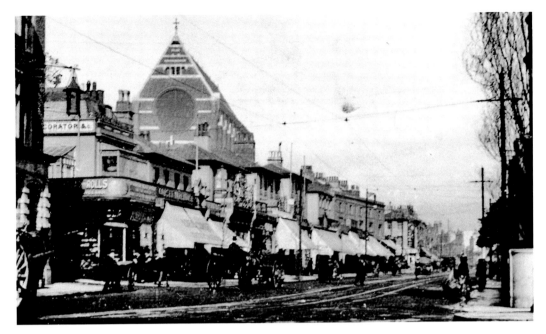

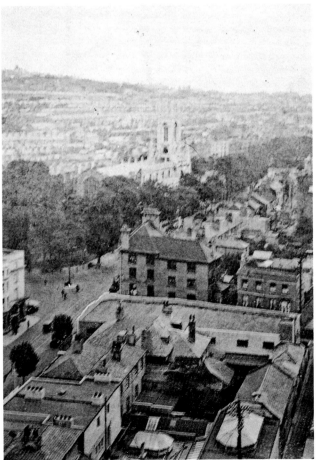

There and Back Again

London Road from Cheapside to Ann Street, around 1910, as seen from York Place. The pre-1820s semi-detached villas were now entirely given over to commerce, although the upper floors were still residential. Madras House, once on the corner of Cheapside, had lost its side garden to Clark's Bread Company and was thus renumbered as 2. Edwin Watts, signwriter, and Mrs Watts of Watts Corset Warehouse traded from Madras House (seen here with a glazed addition to the first floor). Attached to it is number 3, Lincoln House, the residence of Alderman Edward White who gave Preston Park its clock tower. The 1930 reverse view shows the rear façades of the villas. All have had their rear gardens and conservatories built over. Clark's and Madras House were replaced in 1927 by the new Woolworth's store seen on the left. The side wall of the Northern Hotel in York Place appears on the corner of Cheapside opposite.

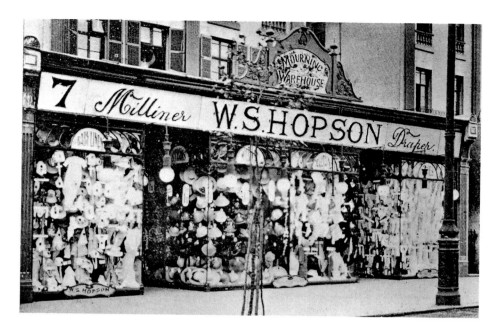

'The House with a Name for Value', 1906

William Samuel Hopson's milliner's and fancy draper's was one of the first large shops to open in the newly commercialised London Road. First opened in 1896 at number 8, it soon expanded into number 7. It also possessed the additional comfort of a 'mourning warehouse' for a society expected to express stages of grief by the colour of its attire. After 1918 it became Ashdown and White's and also acquired number 6. Marks & Spencer replaced the villas with their purpose-built store in 1935/36. A gated gap between the adjacent villas permitted the inhabitants access to their new maisonettes above the shops. Photographs show trellised terrace gardens above London Road's extended shopfronts, thus compensating inhabitants for those lost. Men and boys predominate in the lower contemporary photograph. A cyclist leans with insouciant elegance against a lamp post outside of Brown's ironmonger. Chimney cowls decorate its fascia. The long-standing Corbin's Decorator's shop at number 139 was Brown's neighbour.

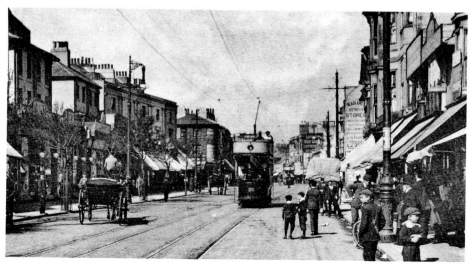

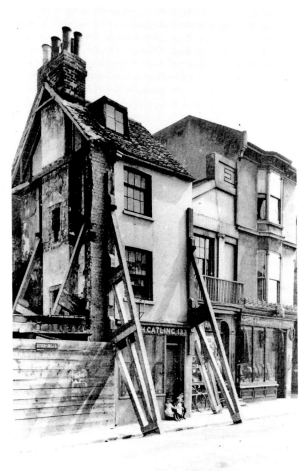

The Old Gives Way to the New: Oxford Place to Brunswick Row

Demolition claims number 132 London Road, the establishment of Mrs Parsons, the wardrobe dealer, on the corner of Oxford Place in 1894. It would be replaced by the smart half-timbered premises of the Tilley Bros, coal and corn merchants. Originally houses, J. H. Catling, the tobacconist, at number 133 occupied a late eighteenth-century example, while those of Stephen Packham, the upholsterer, at number 134, and Frederick Champion, the saddler, at number 135, had once been semi-detached villas of around 1800. These were of singular design. Number 135 had been spoiled by the addition of an additional storey and modernised façade, but originally both houses must have had engaged Ionic pilasters and large windows on the first floor fronted by balconies. Above this the gable was treated as a pediment, with a heavy, flat moulded border and a rectangular acroterion, decorated with a simple key pattern, stood above. Beyond narrow Brunswick Row, George Dudeney's grocery shop occupied 136 and 137.

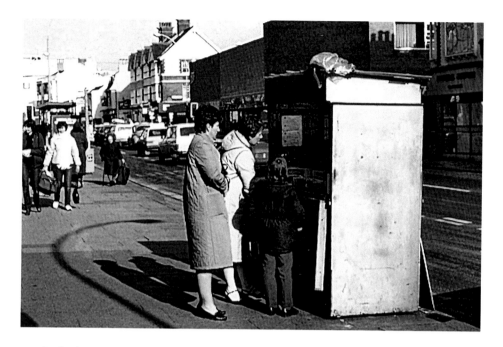

Read All About It

Leslie Whitcomb photographed this group on London Road at the tiny news vendor's stand that for some years stood opposite Brunswick Row and outside the Marks & Spencer building. It was the chilly morning of 17 February 1983 and they were well wrapped up. This was an era of uncertainty for London Road, as businesses such as Marks & Spencer closed their doors and moved to the council's favoured Churchill Square. It had been a destructive decade architecturally. Behind the kiosk can be seen Bellman's 1950s building with its coved entablature at numbers 123–131, then occupied by Fine Fare. Bellman's had become a part of the Coats Paton retail group before it closed around 1971. Between 1970 and 1972, all of the interesting original buildings from Oxford Street southward had been replaced by Boots and Fine Fair's bland extended façades. The pink-washed historic Elephant and Castle at number 113 survived, but is now replaced by typically mediocre buildings.

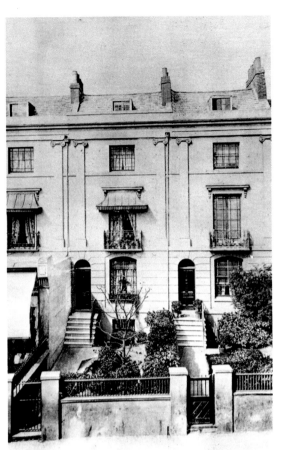

'Eligible Dwelling Houses', 1896 and 1969

A glass slide showing numbers 13–15 London Road in their last gasp of domesticity before becoming shops. With gardens intact, the picture illustrates how delightful the road must have been before the influx of railway housing and industry behind it gradually lowered its social status and commerce usurped it. The western side of the road retains many original façades that, even in their architecturally spoiled state, add both interest and charm. This handsome Ionic terrace postdates the 1826 Brighton map on which its neighbouring semi-detached villas appear. It was built at an angle to afford occupants a more interesting prospect from their drawing room balconies, two of which bear later canopies. The photograph facilitates the reconstruction of similar London Road terraces. In 1969, the terrace and large neighbouring villas appear. Marks & Spencer's Neo-Georgian building replaced villas at numbers 6–8 in 1936. A crossing officer ensures a safe passage for the author and other pedestrians.

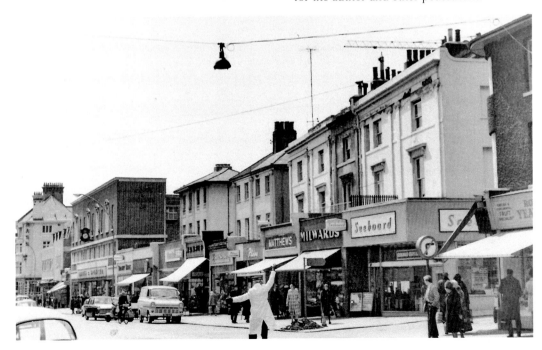

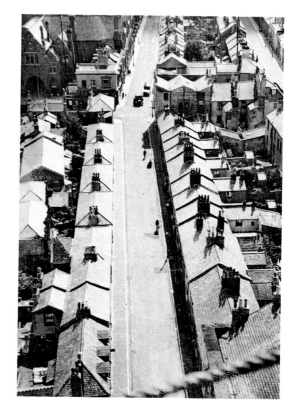

A Missing Piazza

Seen from St Bartholomew's cross in 1930, St Peter's Street crosses Cheapside and links with Pelham Street beyond. Redcross Street and part of Belmont Street appear to the right. The Gothic façade of the board school near the corner of Cheapside appears to the left beyond buildings in Providence Place. Development started slowly in these streets in the late 1820s. The 1968 view from St Peter's Street towards Edmund Scott's great church of 1874 shows the sidewall of London Road Congregational chapel and adjoining houses on the left. These formed an impressive and suitably severe addition to the assemblage. Alas, the opportunity to use these existing assets to create an attractive piazza fronting St Bartholomew's (and through it to revitalise the London Road area) was lost. Houses visually less interesting than those they replaced, together with shop backs embellished with graffiti and arguably one of the most architecturally unremarkable school buildings in England, now surround the church.

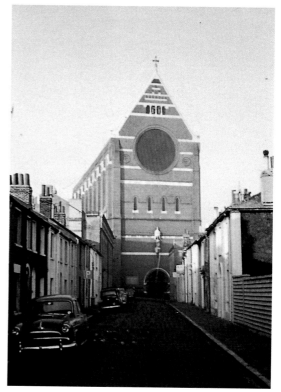

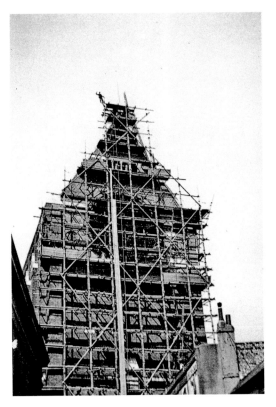

Wonderful Scaffolding: All Tied up!

In 1930, Gates & Sons re-slated and repaired the ridge of St Bartholomew's Church. Writing in *The Evening Argus* on 6 July 1971, J. Elliott recalled his father as having erected the scaffolding and repaired the roof ridge. Scaffolding then consisted of long wooden poles tied together with rope and enclosing heavy wooden ladders. The writer explained, 'My father learned the art of tying poles together when he was a sapper in the Royal Engineers.' The architect and surveyor's firm, George Warr, was also involved in the project, and that circumstance occasioned visits to the site of twenty-two-year-old architect Edward Richard Muxlow (1908–96) and a colleague. Both took cameras. The top photograph shows one of the two swinging on a rope from the top, while below, Eddie's colleague embraces the gilded oak cross on the gable before its removal. Its second replacement was removed in 2014. St Saviour's church appears on the hillside beyond.

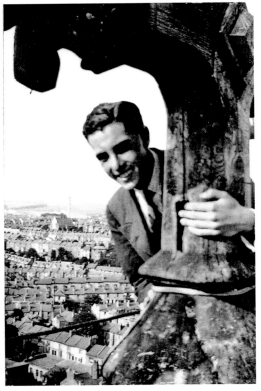

Boys Will Be Boys

In his double-breasted suit and wearing a *boutonnière*, Eddie Muxlow alarmingly straddles the half-stripped roof ridge of St Bartholomew's. The Kodak box brownie in his left hand captured for posterity most of the amazing views of the surrounding streets featured on these pages from 140 feet up. The lower photograph shows Eddie on a previous visit with the roof still intact. Note the tall spaced and decorative terracotta ridge finials that originally enlivened the roof. Since ancient times, long roof ridges have been made visually more interesting by such features. Alas, to the building's visual detriment, they were not replaced in 1930. Both views are closed by the arc of the viaduct bearing trains. To the right appear London Road and the old fire station practice tower. To the left are the streets of a still vibrant community and trees in the garden surrounding the elegant villa at Preston Circus, which had become Lloyds Bank.

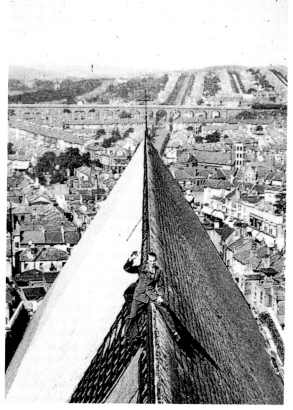

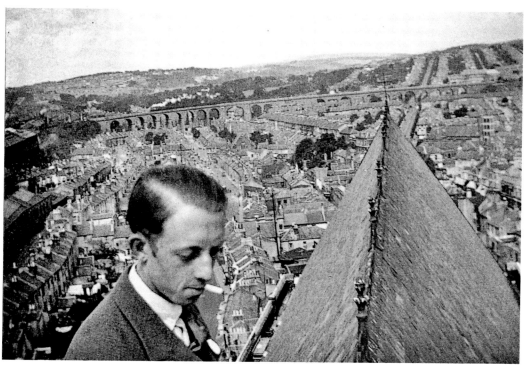

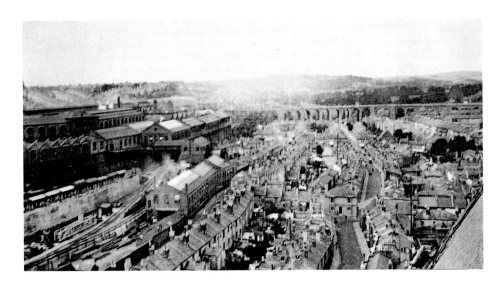

The Lost Gardens of Radynden, 1930

'In 1850 there was little else except gardens between Ann-street and the Montpelier-road [New England Road], the Railway Goods line etc ... that locality not being formed until 1851,' remembered John Bishop in 1880. Until 1841, one ornamental garden above Ann Street curved along the hillside and another historic one stretched south from opposite the Prince's Dairy in New England Road on the site of Rottingdean Hedge Furlong, a garbled memory of the manor of Radynden. By 1851, this former royal delight bore the first streets of railway workers' housing, aligned with the lost medieval fields. The expanding locomotive and carriage works dominated the streets and community below. The top photograph shows London Street ending before a double-fronted house in York Hill, previously the Phoenix Inn, and Elder Street continuing beyond. New York Street runs into New England Street on the left. Gardens are whitened with laundry. The 2014 view looks along New England Street from York Hill.

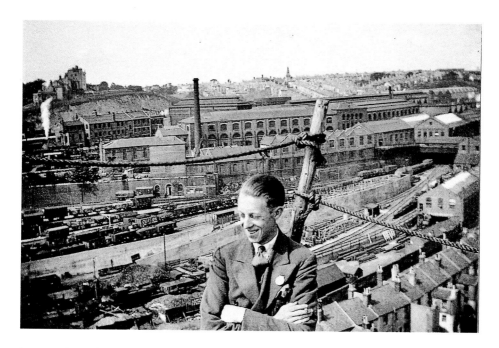

'New and Handsome Workshops Now in ... Construction'

Two rare views of the workshops, marshalling yard and coal depots that had gradually spread down the hillside, as they appeared in 1930 when viewed from the roof of St Bartholomew's. The immense complex of foundries, locomotive and carriage works and drawing offices behind Edward Muxlow's figure is clearly illustrated. Above, on the horizon, St Luke's spire dominates the ridge. Engineering works at Brighton had expanded from 1847 and the first locomotive was built there in 1852. By 1896, some 2,200 staff were employed here by the LBSCR Locomotive Department. Built of yellow brick and supported on arcades, the workshops were boldly classical in style and, when new, must have added a Roman nobility to the hillside. Dirt and extensions gradually marred this. In 1853, an expansion of the goods yard removed Cavendish Place North above Ann Street and in 1897/98, a further expansion of the coal yard displaced 1,000 residents and demolished 171 more houses.

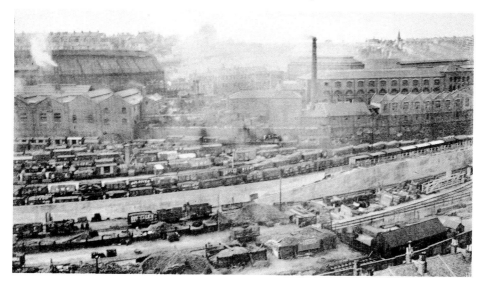

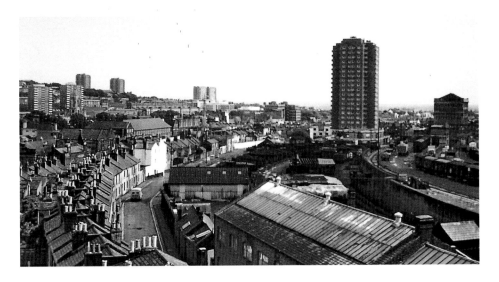

A Lost Community

A view in 1968 from the recently built New England House along New York Street and its continuation, Fleet Street, over a doomed community threatened with compulsory purchase. To the right towers the council's Theobald House from 1966, costing £484,000. The penthouse at the top cost the first residents, Mr and Mrs William Marchant, £4 10s 3d a week to rent, inclusive of rates, heating and stunning views, which was 30s more than their previous council house. Coal and railway yards appear darkly at the near right. On the far left appear the council flats built in the Edwards and St James Street areas. Behind the houses of New York Street in the foreground may be seen the roofs of London, Ann and Belmont Streets. Nowadays, Fleet Street branches to the right, between the blocks of the recent New England Quarter hillside redevelopment. New England Street approximately takes the old course left, and eventually joins Cheapside.

London Street, 'Modest Respectability', 1968
'From Trafalgar Street to New England ...
there were not in 1840 half a dozen streets
and some of these were nameless. At present
there are nearly fifty streets, closely lined
with houses, and thickly inhabited by a
thriving and industrious population, a large
proportion of whom, probably derive their
subsistence from the Railway,' wrote John
Bishop of this area in 1880. Here, London
Street awaits its fate. Demolition had already
claimed the corner of this pleasant but
blighted street with its variety of modest
on-pavement houses. Some façades were
plain, but others had bay windows, aping
their public house, the City of London.
Those pictured show some pretension with
window mouldings and decorated cornices.
At the far right in Ann Street and St Peter's
Street may be seen the enjoyable, but soon
to be demolished, façade of the London
Road Congregational church of 1830. The
towering bulk of St Bartholomew's closes the
view to the east.

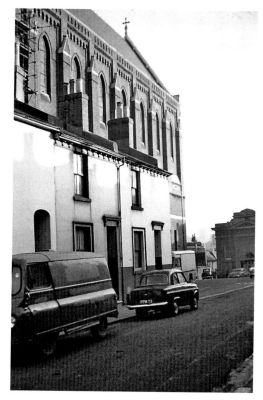

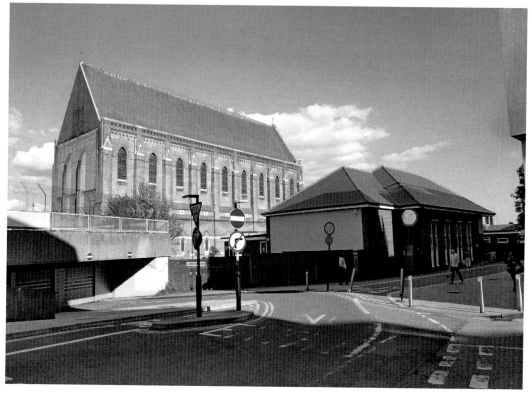

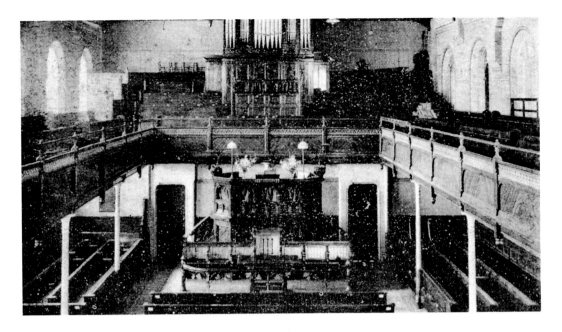

London Road Congregational Church, 1917 and 1930

In July 1830, the London Road chapel opened in Ann Street. Designed by William Simpson, and endowed by local solicitor Henry Brooker for the Countess of Huntingdon's Connexion, it was an elegant classical building with a pilastered façade based on an ancient *templum in antis*. In 1856/57 Thomas Simpson extended it. After 1881 it became London Road Congregational church, and the following year its façade was rendered with Portland cement. Around 1958 it closed and became a warehouse. Alas, it was demolished in 1976 and was replaced by a terrace of houses. Its airy galleried interior was dominated from 1878 by a large pulpit that replaced the original smaller one and from 1917 by an organ made by Morgan & Smith of Hove. Ann Street was in existence by the 1820s but undeveloped. Directories refer to the chapel as being in London Road or, from 1848, somewhat singularly as in 'Ann Street at 17 London Road'.

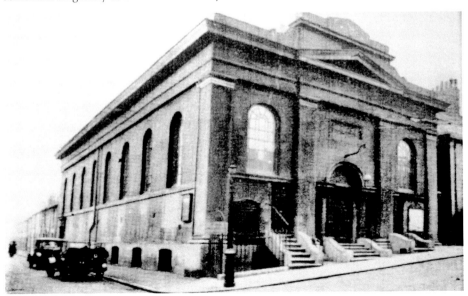

The View to Brunswick, 1930

Eddie Muxlow's photograph from the roof of St Bartholomew's across London Road towards Oxford Place. On the right, two doors away from the half-timbered corner building, appears the narrow London Road entrance to Brunswick Row. Beyond are the parallel rooflines of Queen's Place (once Brunswick Street) erected before 1800 by Charles Sackville, Duke of Dorset. Left of Oxford Place, beyond a vacant lot that by 1934 would host Bellman's Drapers, stretches a terrace of early houses and a charming variety of façades. Some, like Seymour Tingley's pork butcher's, were decoratively painted. Richard Whittington's Shepherd and Dog bears a rooftop hoarding and was one of three pubs in the row. Bellman's would expand into numbers 123–131 by the 1960s, with a façade boasting an illuminated blue-painted coving. This once visually stimulating townscape has gradually been replaced by the visual desert of Boots' and the Co-operative's appallingly bland supermarket façades, which possess, it could be said, all the charms of a prison boundary wall.

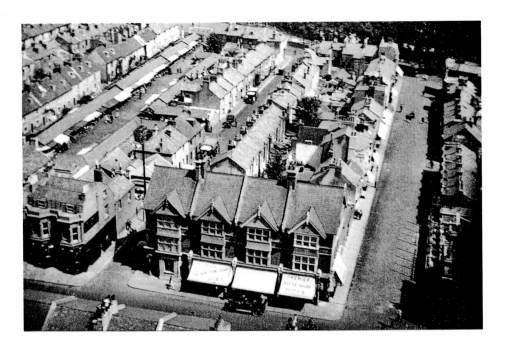

The View Across North Butts, 1930.

Two views of the east side of London Road. This triangular area, bounded by Ditchling Road, is believed to have been where archery was practiced in earlier days, hence its name, North Butts. It was the earliest suburban area to be developed, and its streets follow the direction of the early field system. At the far left, above, appears Baker Street and, fronted by the stalls of the Open Market, George Marshall's 1750s speculation, Marshall's Row. Next is Francis Street and finally Oxford Street. The Elephant and Castle, the double-fronted building on the corner of Francis Street, had been a coaching inn and livery stable when built in 1822. The handsome, gabled 1904 parade fortunately survives. Below, the Mechanic's Arms corners Oxford Street with the Duke of Connaught next door; both have now been lost to Boots' mediocre replacement. The turning seen in Oxford Street accessed the houses of Oxford Court behind London Road. All were demolished around 1936.

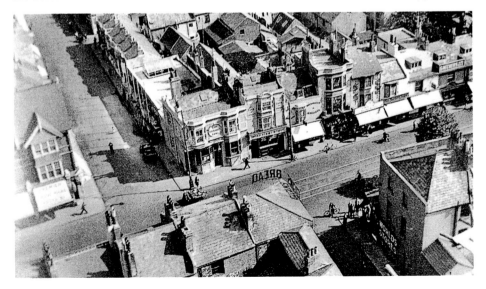

The Open Market in the Late 1920s

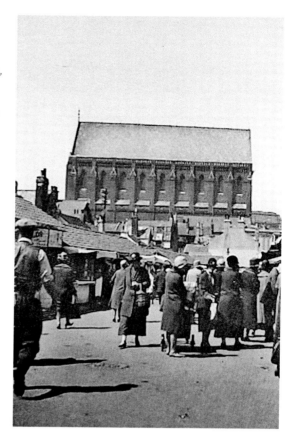

Shoppers search for value at the Open Market, dominated by St Bartholomew's, off London Road. The idea of the market had originated among ex-servicemen after the First World War as a means of making a living. It had unofficially started in Oxford Street but this concern was eventually closed by the authorities, who moved the traders to the Level in 1921. In 1926, the market was again moved to its present site behind Francis Street and the 1750s terrace of cobble-fronted cottages known as Marshall's Row. These were demolished in 1938 to allow the market to expand. Although successful, the market's clientele was mostly working class; middle-class and upper-class women generally shopped elsewhere. Friday and Saturday were the main market days. A 2012–14 regeneration of the market saw the redevelopment of Francis Street seen here. The corner building on the right was once the North Star Tavern and boasts some delightful zodiacal stained glass.

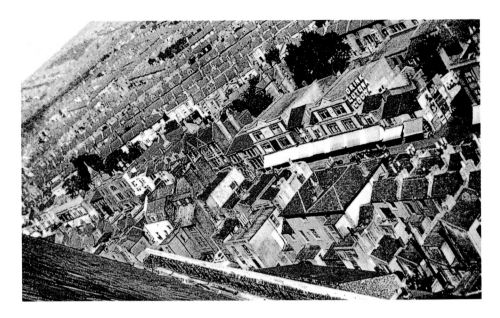

London Road from the Slates, 1930

The strange angle of this informative photograph of London Road is occasioned by the fact that it was taken by Eddie Muxlow while he was perched precariously midway along the roof ridge of St Bartholomew's. Below the parapet, the roofscape illustrates the astonishing variety and complexity of the once domestic late Georgian and Victorian buildings in the road. On the eastern side, the complex of shops that then comprised the Co-op's premises is visually linked by sunblinds and its two purpose-built and pedimented establishments. One side façade urges consumption of Lutona Cocoa. Behind the Co-op one glimpses the bay-windowed houses of London Terrace that expansion would eventually truncate. To the left, beyond the three low gables of the Brighton Labour Club, appear the tower and Renaissance façade of the London Road Primitive Methodist church and schools. Opened in 1894, the last service took place in 2006. It is now the Emporium theatre (seen here in 2013).

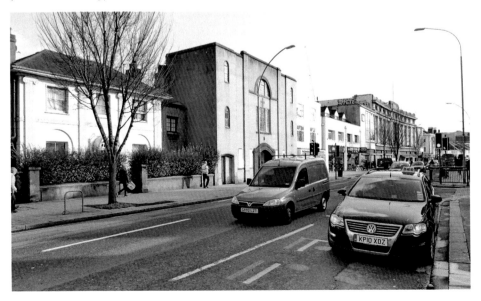

'Good Accommodation for Cyclists': Hurst's Temperance Hotel

In the late 1820s, two substantial semi-detached villas arose opposite the nursery where Baker Street would rise in the early 1840s. They filled a gap between an elegant stuccoed terrace, ornamented with twinned pilasters (and now marred by unsightly tacked-on late Victorian bays), and a group of four early bow-fronted brick houses. The two villas had stuccoed façades with Ionic pilasters rising above rusticated lower storeys. The first-floor drawing-room balcony bore light ironwork with an anthemium pattern. Bedroom windows rose above inset balustrades. Both villas had gardens and were joined to the existing properties by lower side wings ornamented with rustication and a simple panel of labyrinth decoration. In 1864, number 37 (seen here in 1905) became W. Neale's lodging house. By the 1890s it had become dining rooms and, between 1901 and 1908, Charles Hurst's Temperance Hotel and dining rooms. From 1920 until 1935 it was a branch of Rosling's the draper's.

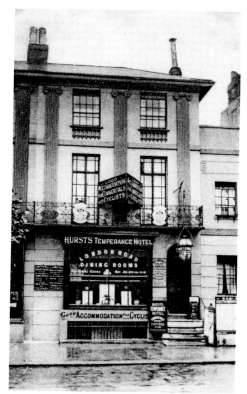

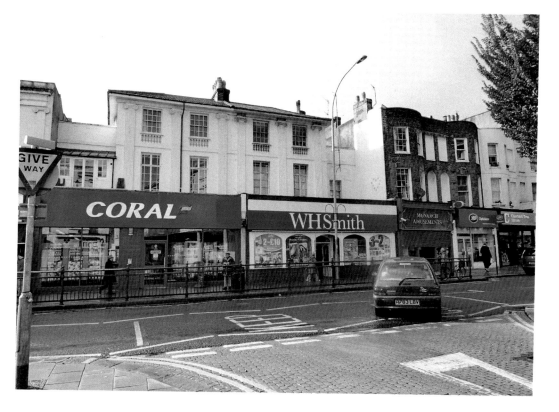

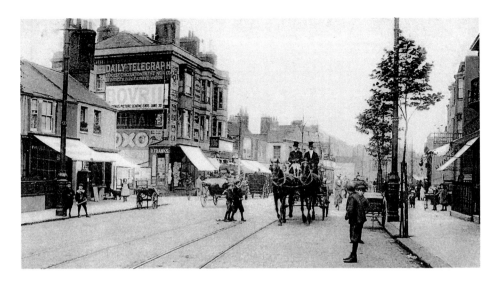

A Gentler Traffic, 1905

Children predominate in this delightful photograph, which looks south along London Road opposite the corner of Baker Street. Carriages and bicycles make up the traffic, although a tram distantly rumbles past the Elephant and Castle. Houses are still intermingled with commercial properties here. On the left, Mrs Gore's garden jostles against Harrison's pork butcher's and Chandler's baker's. Harrison's handcart for home deliveries stands outside his premises. Beyond Baker Street, Franks' stationer's and Kirby's grocery shop shared the large advertisement-plastered building with the Co-op boot store at number 106. On the right, the side wall of Archibald Hunter's chemist's bears a railing for the terrace above. Nyren's pawnbroker sign hangs beyond. The railings and balconies of Hurst's dining rooms and its bow-fronted neighbour (numbers 37–38) appear nearest the viewer. Note the steps to the front door and the basement window, lost features once shared by most houses in the road. Originally, gardens would have stretched as far as the tramlines.

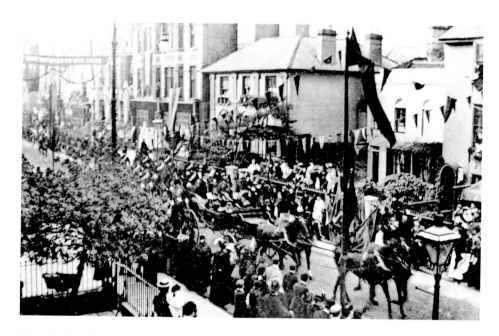

Fête day in Brighton, 9 April 1896

Signwriter George Webb photographed the visiting Duke and Duchess of York's cortège from his balcony at number 38 London Road. It is the finest illustration of how the road appeared while still predominately domestic, and before the council's road widening of 1903 removed its western front gardens. London Road's gardens were noted for their neatness and beauty. Verandas and porches supported roses and climbing plants. Small front gardens often had a specimen tree within a flowerbed, as appears here. Some rear gardens, such as those of the two beautiful late-1820s villas opposite (numbers 95 and 96), were large and included fountains and conservatories. The façade of number 96 had shell-topped windows, suggesting its designer was Amon Wilds. Its neighbour mirrored the surviving number 87, claimed by some to be by Charles Busby. Both numbers 95 and 96 fell to the Co-operative's expansion. Brighton still celebrated then with bunting, pennants and huge flags hung between buildings, as seen in Tissot's painting *Fete day at Brighton* (1875–78).

'Union is Strength', Rise and Fall on London Road

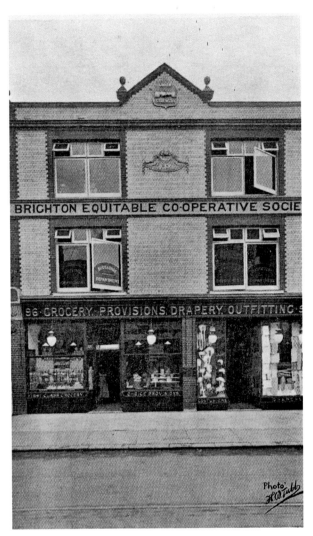

1887 saw the Brighton Co-operative Society founded, and by 1901 it had boot repair and retail premises at 91 and 106 London Road. By 1906, the main office replaced the villa at number 96, although the other premises continued to be listed and were gradually added to over the next thirty years. Two identical new buildings (as pictured) with terracotta embellishments arose at either end of the rank. The Co-op's bakery, dairy, grocery and laundry all made home deliveries. They were resented by private businesses, and especially those owned by staunch Conservatives, who disliked their politics. In 1931, Bethell & Swannell's grandiose department store (seen on the contemporary letterhead below), replaced existing premises at numbers 94–101, bringing retail splendour to London Road. Among its remembered fascinations was the system of pneumatic payment tubes for whizzing money to the cashier's office. Gradually expanded, it eventually failed, closing in 2007. Demolished in 2013/14, the façade is to be retained in a student housing development.

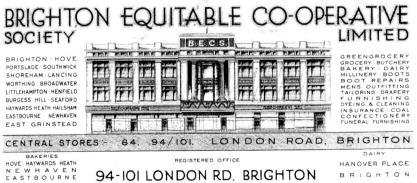

'You Leave the Town, Passing Many Pleasant Houses'

Brighton suffered a tragic architectural loss with the conversion to commerce of London Road. Nowhere else locally did such a variety of late-Georgian, suburban domestic architecture exist. Bordering York Hill, two three-storeyed semi-detached villas with Corinthian pilastered façades adjoin a delightfully elegant pair (numbers 56 and 57) of singular design, unmatched in Brighton. Their architect is unknown. The quality of their stucco work is superb. The composite pilasters bear engraved borders and the balcony windows are uniquely topped by sunflowers. Of particular note are the horizontal attic bedroom windows fronted by acanthus wreath fretwork. Although more elegant, the arrangement recalls the central block of Edward Gyfford's 1806 Ryton House. Locally, it translates classically the tower façades of the Royal Pavilion. There, the horizontal attic bedroom windows have glazing bars composed of quatrefoils. Both villas had side entrances, no doubt grander than in the attempted reconstruction. The 1877 Ordnance Survey map of Brighton informs that these houses' front and rear gardens were heavily planted.

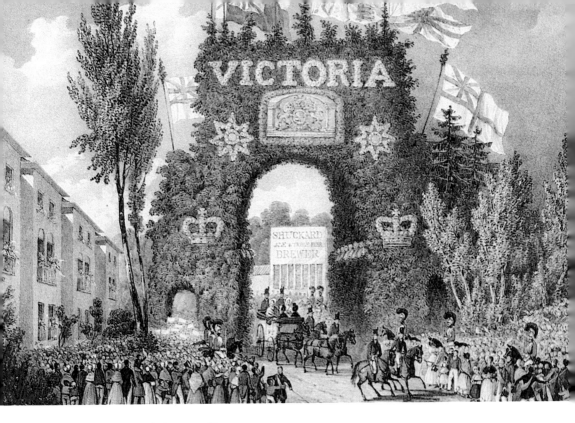

Triumphal Arches and Elegant Villas

At 4.20 p.m. on 4 October 1837, Queen Victoria crossed the Preston/Brighton boundary for her first visit as monarch. Having already passed through 6 miles of cheering equestrian and carriage spectators, she reached the huge 'rustic arch', designed by George Cheeseman Jnr, which spanned the London Road outside the Hare and Hounds. This was covered with evergreens and decorated and 'inscribed' with dahlias. Its southern façade displayed the legend 'Victoria' and the northern, 'Hail England's Queen'. Raised within the archway, a fifty-strong choir sang the National Anthem. Apart from those thronging pavements and house balconies, all the streets entering London Road were blocked with grandstands holding spectators. Before the pavilion's North Gate, another huge floral arch accessed a balconied amphitheatre holding 2,400 gentlefolk. W. L. Walton's lithograph, after Joseph Cordwell, includes Shuckard's brewery and four of the once pretty attached villas that still survive. Most, apart from numbers 64,65, have their upper façades marred by later bay windows.

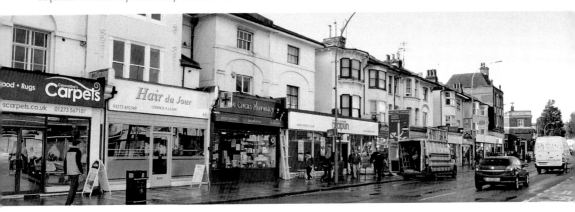

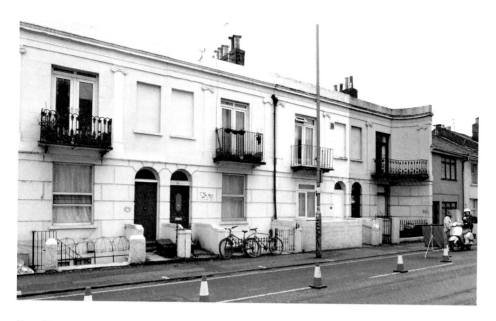

'Small tenements', Viaduct Road

Originally, this was a bridleway to Shoreham, skirting the Brighton and Preston border that became known as Montpelier Road East, 'out of London road'. By 1850, its simple classical terrace of double-fronted villa-cottages had been joined by Viaduct Terrace, named for its uninterrupted view of the 1846 viaduct. When new, with original balconies, windows and entablatures intact, the terrace must have been delightful. The smallness of the houses belies their elegance and architectural ambition. Above the basements, a rusticated ground floor was topped by a blind window and a balcony accessed by French doors. Those at number 10 retain their original glazing. This end house also retains the terrace's most delightful feature, a curving screen wall that hid the rear of the Hare and Hounds from those on the balconies. Ionic pilasters link the houses. Possibly due to the small size of the houses, directories mostly ignored the inhabitants until the 1870s, when most were artisans. It became Viaduct Road around 1877.

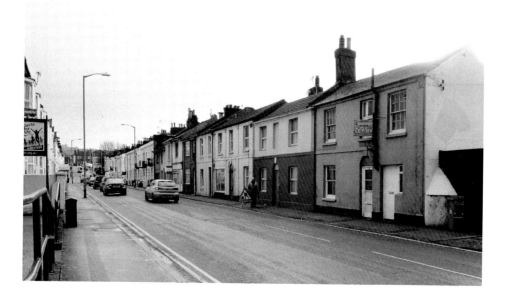

England Expects Brighton to Do Her Duty

Workmen put the finishing touches to a wooden Nelson's Column at Preston Circus during one of the Second World War's 'Warship Weeks'. Its purpose was to alert Brightonians to the importance of sea defence and to encourage investment in war savings. A painted thermometer displayed the results. Brighton and Hove repeatedly raised huge six-figure sums and 'adopted' several vessels. P. C. Brown's adjacent island news kiosk was actually a camouflaged military strongpoint. 'Preston Circus', the 1935 corner parade of shops, replaced Brighton Lodge, the elegant 1830s detached villa. Walled gardens had surrounded it but, by 1906, those on the north and east had been lost to road widening. The earliest of the 1840s railway houses cover the slopes behind. High on the hill to the right stretches the noble arcaded façade of Rastrick's original workshops, designed to complement the adjacent triumphal arch of the New England Bridge. Before later accretions, their effect must have been most impressive.

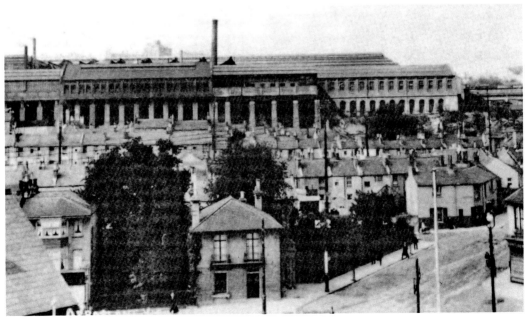

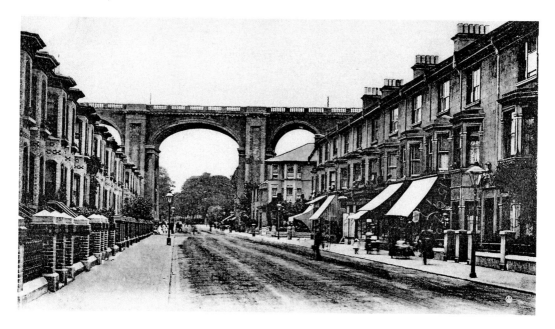

John Urpath Rastrick's Noble Portal, 15 September 1893

Considerable subsidence, discovered in April 1846 on removing centring, occasioned the rebuilding of the new viaduct's principal arch, thus delaying its opening until June. Back in November 1815, Mr Scrase, bailiff to William Stanford, fell prey to armed robbers here. The 1873 northern section of Roseneath Terrace on the left was the road's first development. Its intended name, Lorne Terrace, was changed after a wag painted 'For' before Lorne on its board. The polychromatic façades employ white and red bricks and retain their original ironwork, apart from the gates. The buildings on the right were also private houses. Those built as shops originally had ball terminals at first-floor level. The lower 1905 picture shows the Preston Circus to Preston village horse bus at its terminus. The 1903 directory discloses that number 78 Preston Road housed the intriguing 'Preston Park Toilet Club', managed by the aptly named Mr Leeuw. Alas, its posthumous papers have not survived.

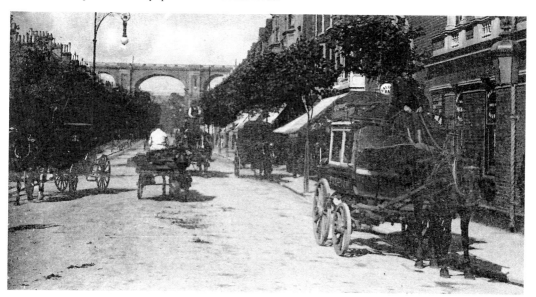

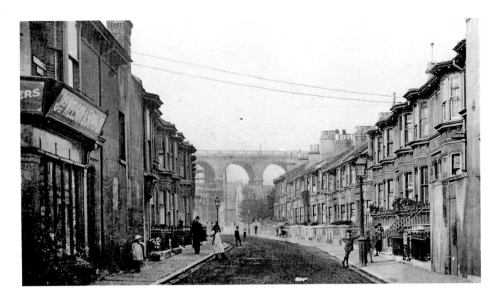

The Dairy Estate, Campbell Road, 1907

Inhabitants stare and balconettes brim with plants in Campbell Road. The Prince of Wales rented the dairy from William Stanford to supply the Pavilion with dairy produce. The main gabled house may have been built as a *cottage ornée*; its tenants were aristocratic. The beautiful grounds, 'embosoming trees' and 'picturesque erections' are said to have witnessed royal *fêtes champêtres*. In October 1814, Queen Charlotte and the court enjoyed a cold collation here, supplied from the Pavilion. Brighton maps show detached pleasure gardens stretching southward behind London Road. The dairy survived in part until the area was cleared in 1871 by Messrs Ireland & Savage for their middle-class 'dairy estate'. This encompassed Argyle, Campbell Roads and Roseneath Terrace on Preston Road. As the roads were laid out on the wedding day of Princess Louise to the Marquis of Lorne, the names were patriotic and referred to her husband's styles and titles.

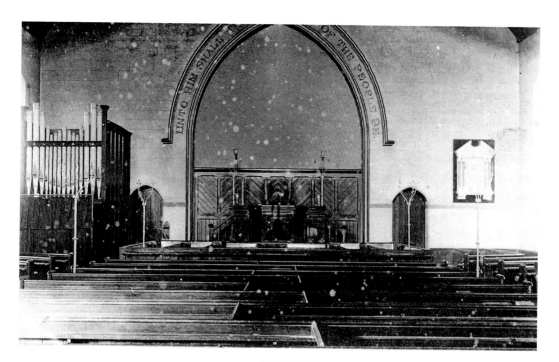

'Unto Him Shall the Gathering of the People Be'

Around 1874, the architect John George Gibbins, of Goulty & Gibbins, designed an Early English-style chapel for New England Road in red brick with Bath stone dressings. Its interior (photographed above before 1919) was very restrained; the only decoration was painted ashlar work above a dado strip, and gilding on the mouldings of the northern arch that framed the inscription used here as the title. First listed in the 1875 directory and called Christ Church Evangelical chapel (Independent), its pastor was Revd James Ade. By 1883, it had become the town mission hall run by the 'town missionary', John Haynes, who had long resided in the road. It later became the New England Road Mission church. Altered in November 1919, it then became a mission hall of St Saviour's. From 1963 it was an Elim Free Church and Evangelical Centre, finally closing in August 1988. It was demolished in the 1990s and replaced by Amber House flats.

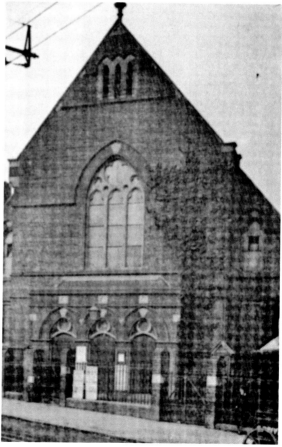

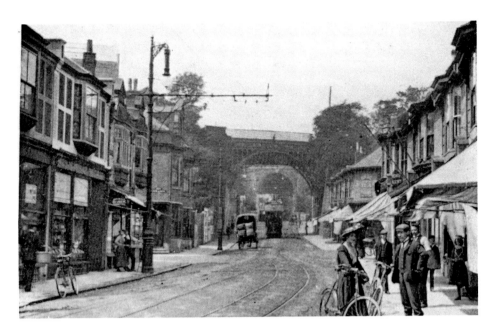

At Preston Hedges, New England Hill, 1900 and 1860

Below New England or Constitution Hill, the road skirted Preston's boundary and, from Preston Circus, bordering the triangular plot holding the Prince's Dairy, had been known as Preston Hedges. With its trees, meadows and gardens, the locale was said to present one of the 'loveliest rural pictures imaginable'. Although the main house facing Preston Road had long gone, the dairy building still survived until 1871 and stood to the right of the picture, just before the goods line bridge. On 12 October 1816, *The Dart* stagecoach disastrously overturned *The Phoenix* while overtaking at the dairy. The 1860 photograph looks north-east from the great chalk mound occasioned by railway construction, across to Hollingbury Copse. New England Farm's trees appear before the 'Montpelier viaduct'. Preston viaduct stretches across fields bristling with stooks. Tiled, wooden carriage sheds, 100 yards long, occupy the later site of London Road station. The southern one collapsed in a gale on 1 November 1863.

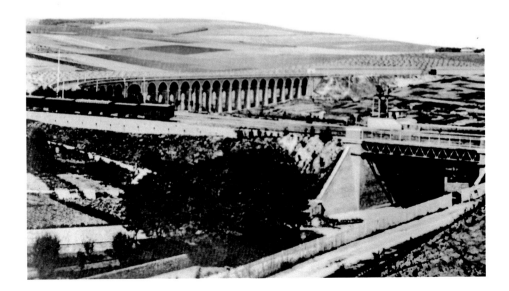

Grove Villa, New England Farm, York Grove

'The pretty triangular field at New England in front of what was originally Murrell's (Chatfield's) Farm – and subsequently, Harry Pegg's of the Royal York Hotel, which was intact in 1850, was in 1870 covered with houses; nought remaining of its pristine state but the two or three trees growing near the Bridge Inn adjacent to the Montpellier-road Viaduct.' Thus wrote John Bishop of New England Farm (and laundry) in 1880, recalling how Brighton's amazing growth since the 1840s had swallowed up the countryside. Remarkably, the farmyard buildings survive, as does the elegant 1810–20s farmhouse with its delightful Tuscan porch based on a *templum in antis*. By 1864, it was called Grove Villa, but by 1911 its formal gardens, which constricted Old Shoreham Road, were covered by houses. Photographed in 1987, the farmhouse was twice threatened with demolition in 1988 but survived. York Grove (1864) and York Villas (1870) enshrine Pegg's connection with The Royal York.

37

Walk 2

In the Shadow of the Rome

Numbers 2 and 4 Stanford Avenue, Stanford House and Chesham House respectively, as they appeared in 1976. Probably the first houses to be constructed in the Avenue around 1878/79, they were to enjoy a prime situation opposite the park entrance when it was ceremonially opened in 1884. Stanford House was the residence of John Whittome Esq., and Chesham House that of Mrs George Gates. Both houses were grand properties with cast-iron balconettes clasping the front bays. Stanford House was enlarged before 1900 by an east–west room with a canted bay that still retained its wooden sunblind boxheads in 1976. This room was memorable for the sculpture of a recumbent lion above its western bay window. Thirty feet south of this, a Roman building was discovered in 1877. Recent suggestions that it was a temple, rather than domestic structure, seem unjustified given the complexity of that portion of the ground plan excavated.

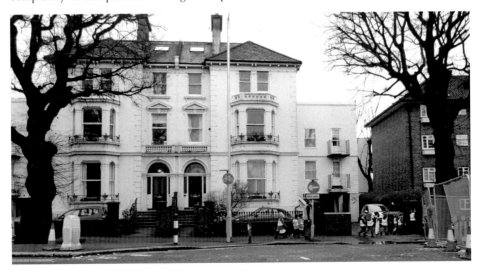

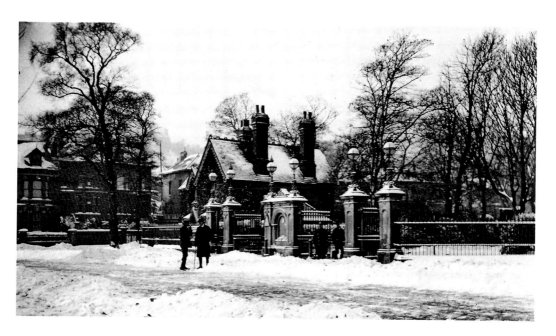

Open for Business, 30 December 1908

'A gateway worthy of the park would, for instance, be an acquisition', wrote John Bishop in his 1892 edition of *A Peep into the Past*. Philip Lockwood's dolphin-topped gates date from 1883 and, presumably, are those despised by Bishop. The dolphins survive today on park balustrades, minus their vandalised flambeaux. The ironwork cost £5,098 and was cast by James Longley of Crawley, as were the splendid railings that once encircled the park but now only survive on the western side of the cricket ground. This delightful photograph, by Percival Hammond of number 78 Beaconsfield Road, shows the entrance, its lodge, and some of the lost villas of Preston Road. The snowstorm of 29 December 1908 covered Brighton with a foot of snow. Only intrepid pedestrians and the ubiquitous policeman appear abroad. The much-admired ornamental lodge (demolished 1928) was from the start the home of the Park's landscape designer and corporation gardener, James Shrives.

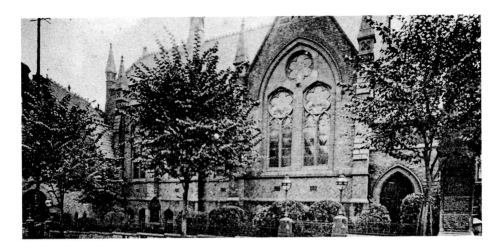

The Preston Park Brotherhood and the Liverpool Connection

In 1884, the Wesleyan Iron church at the corner of Dyke Road Drive was replaced by a new building. It was designed by the Liverpool architect Christopher Obie Ellison (1832–1904) and was of brick with terracotta dressings. Notwithstanding that it was in Dyke Road Drive, and its eastern façade was blocked by the 1880 Preston Road School, it was called the Preston Road Methodist church (later, the Preston Park Wesleyan church). Below its nave, transepts and organ chamber there was a vestry, a classroom for 400 pupils and an infants' room. Ellison built other Brighton Methodist churches in Norfolk Road and Dorset Gardens. It closed in 1943 and became business premises until demolished in 1974 for an office block. In July 1912, the members of the church's Preston Park Brotherhood presented their president, the Reverend E. Harold Chappel, this group portrait to celebrate his marriage. This male-only group had their own service at 3 p.m. every Sunday.

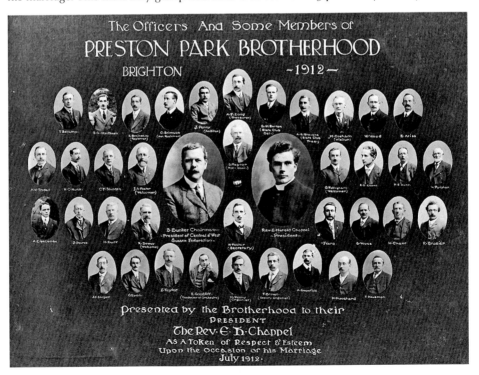

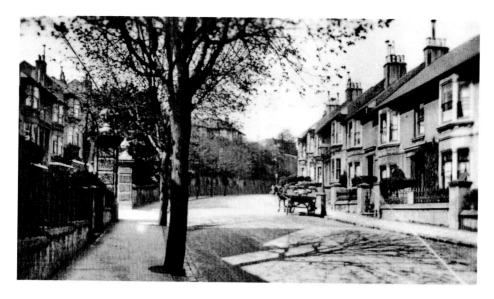

The Drive to the Dyke Road

Dyke Road Drive, seen around 1906 from outside the Wesleyan church. The road was cut into the steep hillside below the railway embankment around 1879/80, and many of its houses were built by the Holloway Brothers. Their builders' and decorators' premises were at number 1a Dyke Road Drive, between 1881 and 1931. Sufficient land was only available for housing on one side of the road. The Holloways' ingenious solution to this lack of development potential was to first cut Parkmore Terrace (1880) into the hillside above at a higher level. Its pleasant, unostentatious houses were approached through grand and rusticated gate piers, now sadly damaged. Bombing blasted its upper houses on 25 May 1943. Both sides of the entrance to the Holloways' yard opposite were also rusticated and partially survive, albeit altered. Percival Joseph Hammond, the prolific Edwardian trade photographer and postcard publisher, had his Classic Studios premises at number 36 Dyke Road Drive for several years.

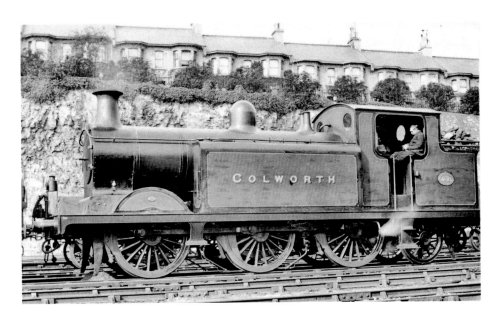

Colworth from Dyke Road Drive

A view from the upper goods entrance on Dyke Road Drive, looking across to the houses of Park View Terrace in Stanford Road that were built in 1882/83, high above their man-made cliff. Originally, the hill sloped naturally down to the Preston Road, only traversed by Lovers' Walk. Then a railway embankment was made for the main line, before the hill was eventually drastically cut back to first accommodate the paint shop below Hamilton Road, and then the increasing number of tracks required for the goods sidings. Bombing in May 1943 showered railway debris on the damaged houses and gardens above. The stationary London, Brighton & South Coast Railway locomotive, number 406 *Colworth*, here preparing to commence shunting, was an E5 Class 0-6-2 built in November 1904 and withdrawn in 1951. Dyke Road Drive, together with many of the villas of the Preston Road, was built on land once occupied by Preston Dairy Farm.

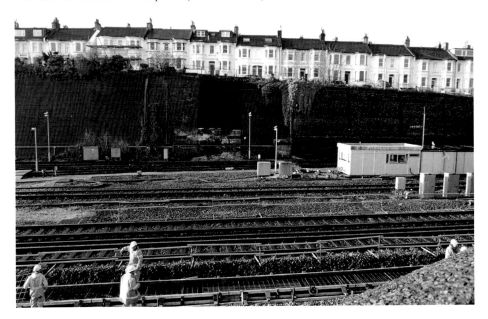

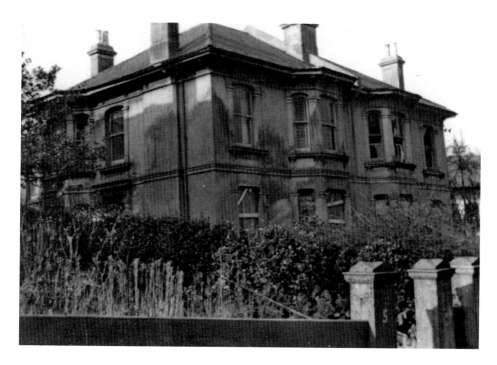

The Remains of Lovers' Walk

Originally, Lovers' Walk ran to the north of Preston dairy farm (also known as 'Chandler's Farm') from Preston Road. The walled twitten continued diagonally up the hillside towards the Dyke Road, where Hamilton Road now joins Stanford Road, and ended at what is now the Seven Dials. It passed a few scattered buildings within arable enclosures en route. A railway embankment was later constructed along the hillside above to accommodate the double track, and a bridge was built so that the twitten could continue on its traditional route unimpeded. Around 1878/79, the whole hillside was removed and then a high artificial embankment, bearing the new Dyke Road Drive, sealed off the western end of Lovers' Walk, hard against the farm's cottages. Flights of steps thereafter connected the truncated Walk to the new road. Houses were built in Lovers' Walk in 1880. The photograph shows numbers 6 and 7, Heasmonds Lodge and Dunfyrthing, in 1970, before their replacement by offices.

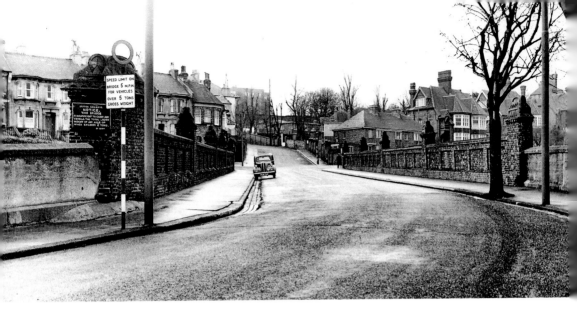

Bridging the Gap

The construction of a road between the Drive in Hove and Preston Road commenced in the late 1870s, coinciding with the massive expansion of the sidings to the north and south above Lovers' Walk. From the Upper Drive, the new route was constructed around 1880/81 along the cliff, before joining Stanford Road and Porthall Avenue. It crossed the newly expanded sidings on an iron, brick and moulded terracotta bridge, before continuing down to Preston Road. The photograph by Deane & Millar is dated 3 December 1956 and looks directly towards Porthall Avenue. High on the hill is the square block of flats that replaced Bleak House on the Dyke Road. Below it appears the eastern gate to neighbouring Highcroft's infilled grounds. To the left appears the attractive Port Hall Tavern and houses of Park View Terrace in Stanford Road. Right of the bridge, the architecturally ambitious, tile-hung Highcroft Villas of 1883 line Dyke Road Drive.

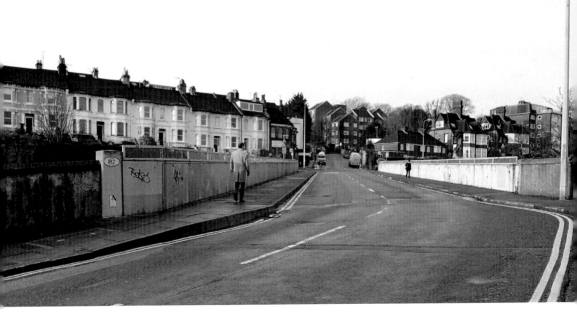

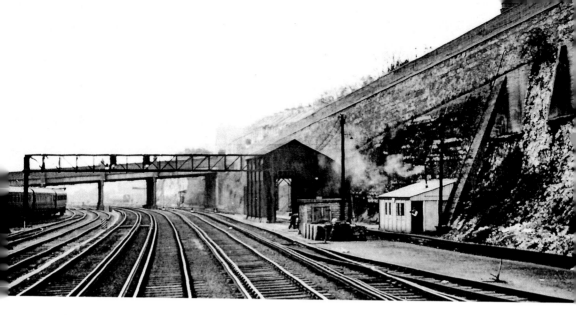

Dyke Road Drive Bridge

Henry Cyril Casserley (1903–91) photographed the Dyke Road Drive bridge from opposite The Rookery on 24 April 1937. His photograph displays how the original dipping contours of the hillside on the right were here greatly embanked in order to allow the new road above a gentle gradient down to the bridge. The lower 1956 photograph by Deane & Millar reverses their previous view and looks towards Preston Park. It displays the cast-iron column girders, brick-panelled parapets and moulded terracotta piers. Unable to bear the weight of modern vehicles, speed and weight restrictions were strictly enforced. Loads of 2 tons (rising to 5 tons later) were the maximum permitted and speeds were not to exceed 5 miles per hour. It was finally closed and replaced over two years from 1960 by a utilitarian structure. Daredevil 1950s Barnado boys would tightrope walk the clifftop parapet on their return from Stanford Road School to their Furze Court home.

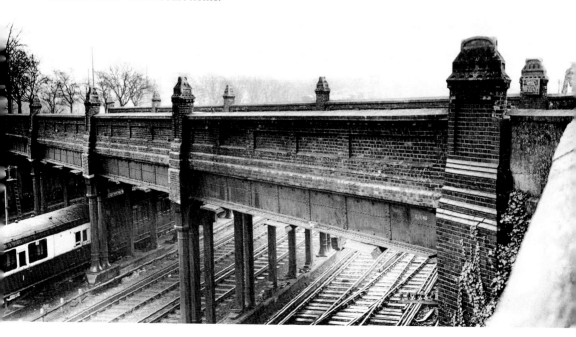

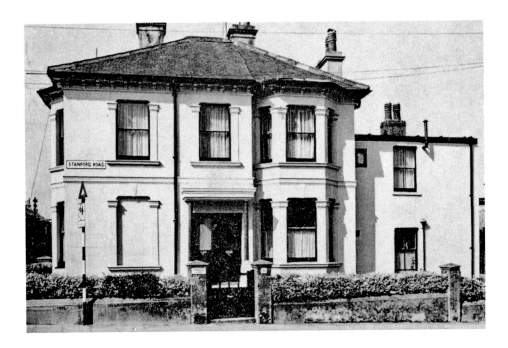

On the Borders of Prestonville

'Prestonville was projected in 1865 by Mr Daniel Friend, on land to the north of New England Farm ... The carriage road, which subsequently formed its western boundary (that is Stanford and Prestonville Roads), totally obliterated the upper portion of that once pretty rural retreat known as "Lovers' Walk" ... The township of Prestonville covers 6½ acres. The site – so little was Borough extension in this direction then anticipated – previously to its purchase by Mr Friend, had been fixed upon by the Town Council for the purpose of a public abattoir,' recalled John Bishop in 1880. The rough triangle of Stanford Road, Hamilton Road and Brigden Street originally formed the boundaries of this middle-class estate. In the 1890s these were joined by Stafford, Buxton and Lancaster roads. Edward Beves and Francis Tooth built Stanford Lodge, Number 51 Stanford Road, in 1892 (photographed 1963). Previously living at number 73 London Road, Daniel Friend later built and resided in substantial Highlands opposite (*seen: below, right*).

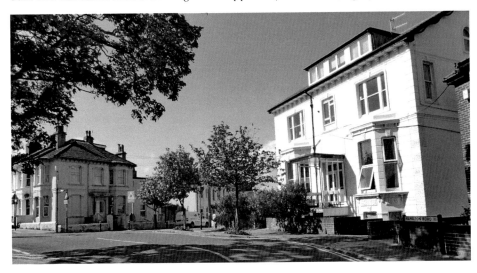

St Lukes's Prestonville

St Luke's, Prestonville, arose around 1873 and replaced an iron church that had itself replaced one built in 1871 and destroyed by fire. Previously, the site on the Old Shoreham and Stanford Roads had been part of Smyth's flower nursery, one of many around Dyke Road. St Luke's opened in 1875 and became Prestonville's parish church from 1878, when it was decided to divide the old Preston parish to cater for the rapidly expanding suburban areas. It was designed by John Hill in an Early English style. John Gibbins, the architect of Brighton's Italianate Municipal Art School, enlarged it in 1882. Polychromatic in its use of red brick and Bath stone, and with a clock tower and spire at its south-east corner, it is a pleasant enough building. Desperately out of fashion by 1965, architectural writer Ian Nairn would, unkindly, refer to it as 'poor'. The 1972 road scheme threatened both St Luke's and its vicarage with demolition.

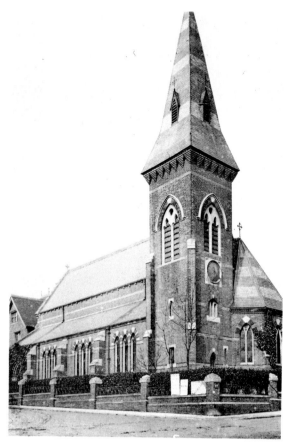

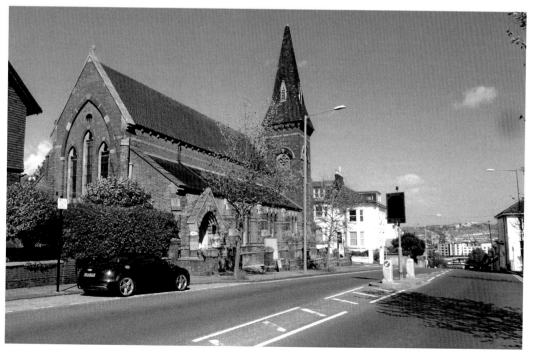

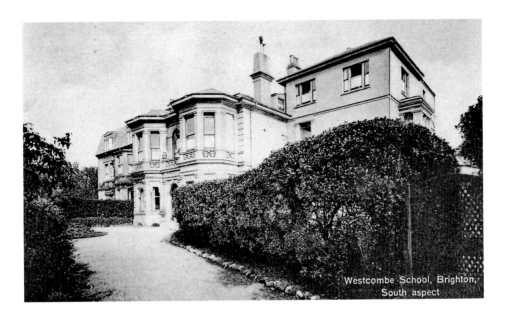

Westcombe School, Brighton, South aspect

'Perfect Young Ladies Are We'

Westcombe Ladies School on the corner of Dyke Road and Old Shoreham Road, photographed around 1920, was one of several such establishments clustered around this educational crossroads. Built before 1846 and named Belvoir Lodge, it was the Brighton villa of John Russell Reeves, a China and East India Merchant and naturalist. He was the son of plant collector and tea inspector John Reeves, whose collections are now in the British Museum and the Natural History Museum. Russell changed the name to Hove Place in 1850 and to Hove Place House by 1859. Later, a changing array of tenants saw it described as 'a furnished house' by 1897. By 1901 it had been taken by Miss Stevens, altered and had become Westcombe. In 1935 the school moved to Furze Court. The Territorial Army occupied Westcombe during the Second World War (*see below*), and it was afterwards compulsorily purchased to house families. In 1956 it was sold and demolished for Westcombe flats.

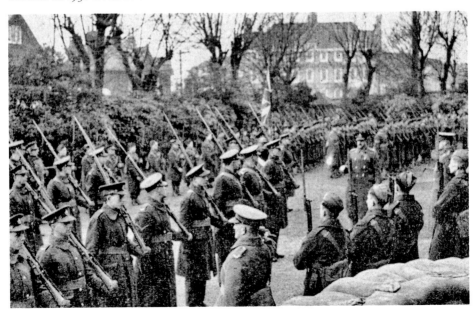

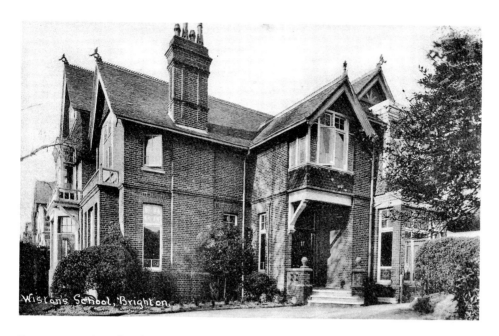

Dragons at Wiston's School

Around 1886 a large multi-gabled house called St Margarets arose on a kite-shaped piece of land bounded by the confluence of Dyke, Chatsworth and Old Shoreham Road. Brick built and tile hung, its gables were topped by dragon finials, probably the products of Meads of Burgess Hill. The house owner was Edward Beves JP, who is first listed there in 1887. He was a timber and slate merchant and, with his partner Francis Tooth, had purchased parcels of agricultural land in the area in 1885 (*see page 46*). Beves and his considerable family occupied St Margarets until 1913. Following several years of unoccupancy, or possible wartime use, in 1921 Wistons Ladies School moved in from their earlier neighbouring address. The school lasted until 1967 and in 1969 planning permission was granted for twenty-one flats to be built. A proposal for town houses followed. The house was eventually purchased and enveloped by the British Pregnancy Advisory Service's Wiston Clinic.

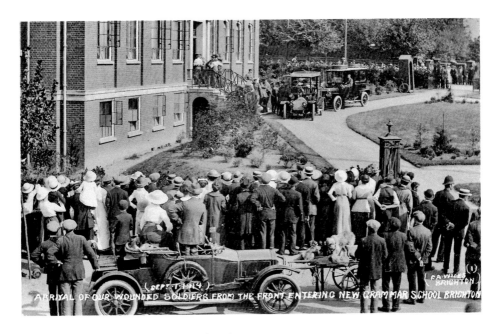

ARRIVAL OF OUR WOUNDED SOLDIERS FROM THE FRONT ENTERING NEW GRAMMAR SCHOOL BRIGHTON

'It Makes Your Heart Ache to See Them'

Wednesday 17 September 1913 saw the opening of Samuel Bridgman Russell's handsome Brighton Hove and Sussex Grammar School at the confluence of Dyke and Old Shoreham roads. Within a year, however, the school was requisitioned to become the Eastern General Hospital to cater for injured troops returning from the Front. Their arrival in September 1914 caused a patriotic frenzy among Brightonians and Hoverians, and they became an attraction. Wiles of Hove even issued postcards. Crowds stood ten deep outside the school to gaze at the 'poor Tommies' relaxing on deck chairs before them. Nan, who sent the lower card, informs that she had been to see them, but that there were only 350 left and that some had left that day and seemed eager to be at the Front ('they did get some cheering'). Brighton Grammar's long and academically distinguished history has now been inherited by the co-educational Brighton Hove and Sussex Sixth Form College.

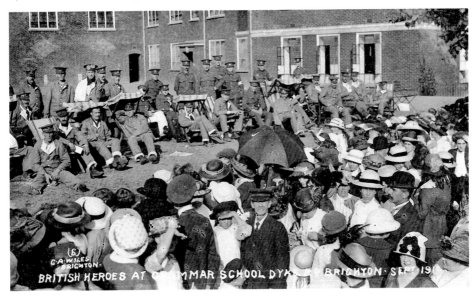

BRITISH HEROES AT GRAMMAR SCHOOL DYKE RD BRIGHTON · SEP. 19

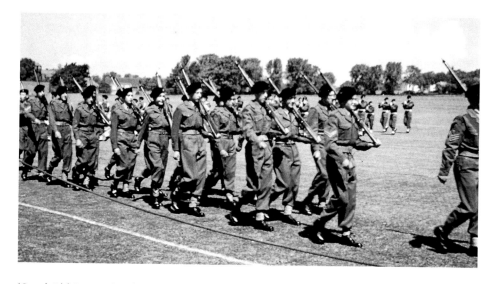

'Good Old Sussex by the Sea!' BHSGS on Parade

To strains of Ward-Higgs' 1907 patriotic marching song 'Sussex by the Sea', the author and fellow members of the Signals Regiment take part in the march past on the extensive school playing fields between the Dyke and Old Shoreham roads. The occasion was Brighton Hove and Sussex Grammar School's annual CCF General Inspection Day in 1964. The school cadet force encompassed Army, Navy and Air Force units and boasted both a glider that rested on the school playing fields, and dinghies kept on the beach at Hove. Friday afternoons were devoted to training from the third form onwards for four years. The lower photograph shows the school's Signal and RAF hut, next to the twitten leading from Dyke Road. The author (*second right*) takes orders from Ian Maclean, the much loved geography master and Deputy Head. The signal's hut proved a useful, if unauthorised, venue for 1960s cadets to listen to the pirate station, Radio Caroline.

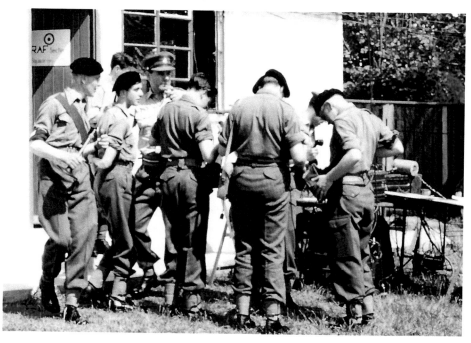

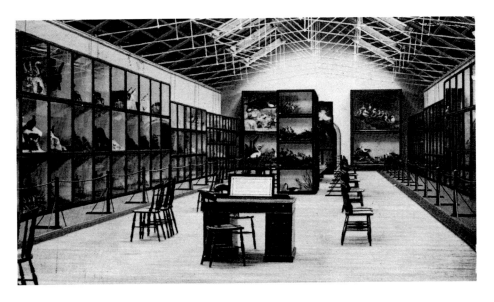

'We Have Been in this Place. It Was Alright, I Suppose'

Booth Bird Museum in 1907, when it failed to inspire Edith, who sent its image to her friend in Bromley. The positioning of this important museum in Dyke Road, away from the centre of Brighton, is accounted for by the fact that it was originally Edward Thomas Booth's private collection and built down the northern side of the extensive gardens surrounding his lost mansion, Bleak House. Booth (1840–90), moved to the then isolated house in 1865 and built the semi-private museum for his collection in 1874. Obsessed with ornithology, he shot birds and then had them mounted in diorama cases, mirroring the habitat in which they had lived and copied from his on-site notes. Stories credit him with keeping a private train (or at least a railway carriage) ready to whisk him to Scotland when eagles were nesting. The collection was bequeathed to Brighton and has been greatly augmented by additional natural history collections since.

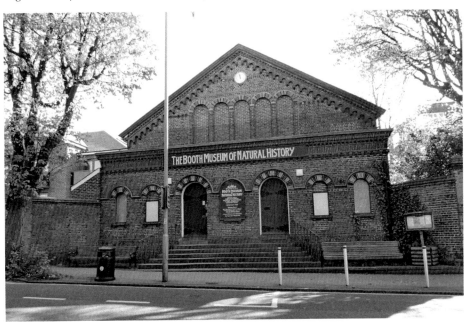

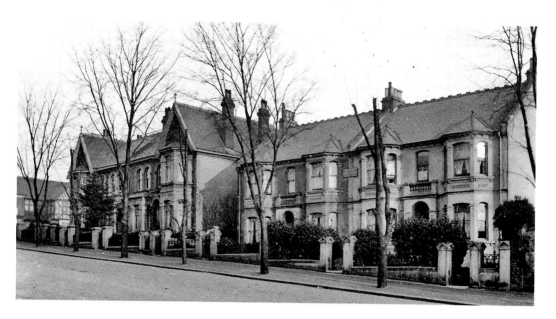

Villas of the Upper Drive

Four large semi-detached villas arose in open countryside at the south-eastern end of the Upper Drive between 1891–99. They adjoined the grounds of the Convent of the Sacred Heart that occupied the rest of the roughly triangular insula between the Dyke Road and Old Shoreham Road. The earliest one on the right was called Maycroft Villa, while its attached companion was known as Maycroft Cottage (later just Maycroft). Together the pair were entitled 'Maycroft Villas'. The neighbouring later and gabled houses, near the corner of Dyke Road, were known as Cefn-y-mor and Lattenburg. The half-timbered façade of the Dyke Road Hotel, the large and genteel 1895 replacement for James Trusler's Windmill Inn, appears behind at the far left. Behind it, until 1885, stood the Black Windmill. This was the famed windmill that in 1797 had been drawn 2 miles from the site of Regency Square to the top of Miller's Road by eighty-six oxen.

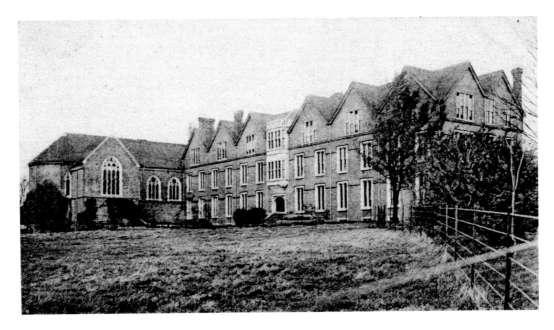

'Building Their Own Prison': the Convent of the Sacred Heart School

The 1893 directory calls the Upper Drive 'Convent Road, a continuation of Dyke Road Drive' but, by 1895, it had achieved its modern name. Until the late 1870s, a dew pond straddled the road's intersection with Old Shoreham Road and a chalk quarry lay westwards. Nothing appears on the 1879/80 map of the site, but the main convent building and landscaping of the grounds by the sisters must have been well underway by 1893. Drains were laid to the Bailiff's cottage in 1894. The Convent of the Sacred Heart is first listed in the road in 1895. Plans for new schoolrooms, laundry and a south wing are dated 1902, 1903 and 1904. Both photographs were taken around 1900, prior to the addition of the new wing. Dairy cattle graze in the convent's fields before the east façade. The Convent School left in 1966, finding the town's morality 'unsuitable'. Cardinal Newman Catholic School now occupies the complex.

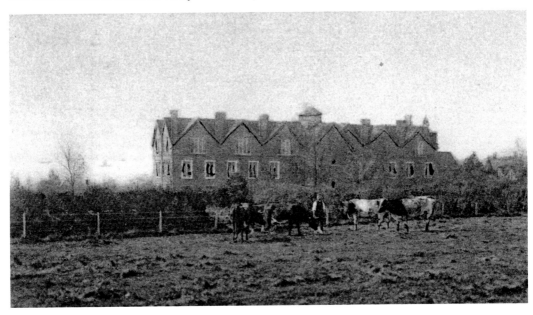

In the Swim ... Another Melbourne

Melbourne House, Dyke Road, arose around 1909. Its rendered 'half-timbered' façade followed Edwardian fashion, but was enlivened by interesting art nouveau details in the veranda woodwork and gable window. It was the residence of Brighton-born solicitor and councillor, Louis Meaden (1871–1937), a highly esteemed member of the Brighton Swimming Club from 1888, and president of other amateur swimming associations. Meaden's remarkable international lineage included Charlemagne, William I and Alfred the Great, to name but a few. In 1927, having visited Florida, he unsuccessfully campaigned in Brighton for the council to build a copy of St Petersburg's new 'Million Dollar Pier'. Meaden's daughter, Mrs Phyllis Field (1903–2002), lived in the house afterwards and is probably seen sitting in the silver Triumph Roadster. The date is around 1950, as Melbourne was divided to include a flat after 1949 and the gate piers display numbers 191 and 191a. Around 1954, Dyke Road was renumbered, and Melbourne became number 312.

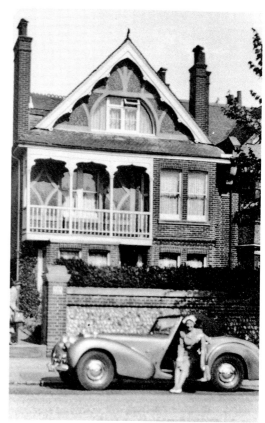

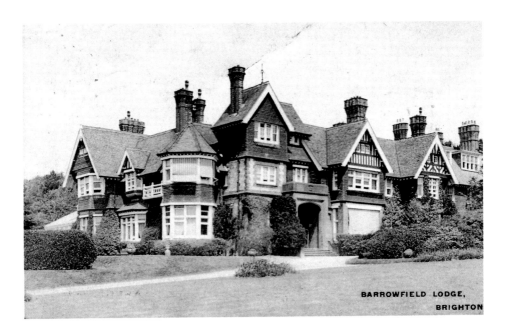

BARROWFIELD LODGE,
BRIGHTON

A Nest of Radicalism: Uplands, Later Barrowfield Lodge

Charles E. Clayton and Ernest Black built 'Tudoresque' Uplands in its vast gardens between 1885–87 for the radical politician and proprietor of *The Examiner*, Peter Alfred Taylor (1819–91). Illness had brought the beneficent Taylor to Brighton in 1873. In 1890 he moved and Uplands, 'a pretty house with beautiful grounds', was sold to fellow radical, Horace St George Voules (1844–1909), for £11,000. A businessman described as 'one of the last of the old guard of journalists', he was a hater of hypocrisy and cant, and the force behind Henry Labouchere's sixpenny radical journal, *The Truth*, which they founded in 1876 and was famous for its fearless exposés. Voules sold Uplands to Lord Newlands weeks before his death and died there. Newlands (1851–1929), distancing himself from radicalism, changed the name to Barrowfield Lodge and resided there until his death, after which the house became flats and the estate was developed. Lady Mary sent this card on 16 September 1916.

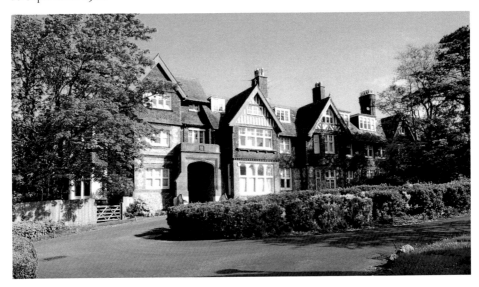

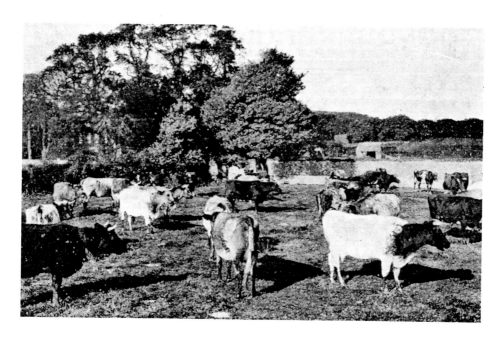

Hygienic Dairy Farms

Farms, nurseries and 'graperies' once lined Dyke Road and largely continued until the late 1930s. The top postcard was issued by Messrs Brook & Sons, dairymen whose main shop and office was at number 102 Western Road. From around 1900 they had operated under the name Montpelier Dairies, but by 1930 they had become Brook & Sons. The card advertised the rurality of their farm on the Dyke Road. Unfortunately, directories do not state which of the dairy farms Brook's was, although the abundance of trees in the landscape suggests one in the Tongdean or Withdean area and possibly Tongdean's Halfway House. The Belgravia Dairy Co. of the same era, apart from owning eleven shops, also boasted Tongdean and Lower Tongdean farms, Redhill Farm and the Home Farm at Withdean in their empire. Sidney Hole, of Hole's & Davigdor Hygienic Dairies, ran Preston Farm in the Droveway. The 1916 photograph shows haymaking completed off the Dyke Road.

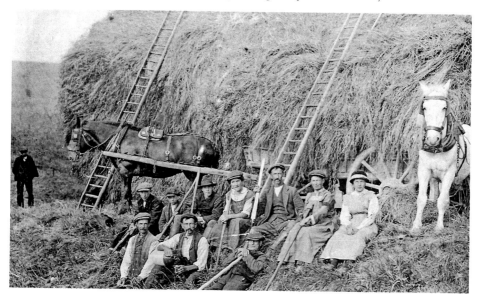

'The Affair at the Khojak Pass...'

Furze Court was a large mansion with an interesting brick and flint panelled façade set in grounds adjoining those of Uplands, on the western side of Dyke Road Avenue. It was built around 1897 for Lt-Gen. Francis Shrubb Iredell, a retired veteran of the Indian Mutiny, the Afghan War and the Argandah Valley. For these services in the Indian Army he was mentioned in dispatches. Iredell lived at Furze Court until 1919, when he moved to number 7 Harrington Road, dying there in 1924. The house was let and in 1925 bought by Lawrence Frederick Harvey, who founded a Catholic boys' school and employed Albert Gilbert Scott to enlarge the property. In 1933, the venture failed, and by 1935 Westcombe Ladies' School (seen here) had moved there. In March 1948 the property became a Dr Barnado's home for boys. This became mixed in 1960 but closed in December 1962. Neo-Georgian Chalfont Drive had arisen on the site by 1969.

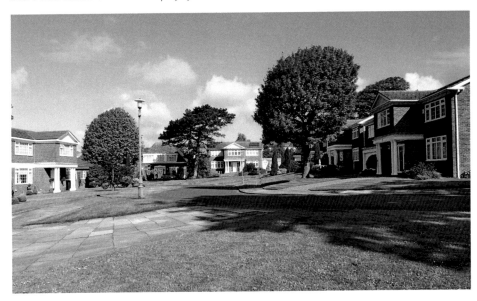

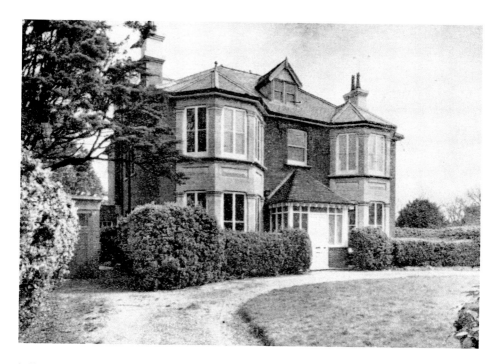

'Affording First-Class Facilities for the London Business Man'

Berea House, number. 36 Dyke Road Avenue, as it was in 1960 when it sold for £8,350 at auction. A detached, double-fronted, brick-built residence, standing in half an acre of garden, its situation was still described as 'semi-rural' even as late as 1960. Built for Henry 'Harry' Sweet in 1898/99 on land purchased from the Curwen estate, stables were added in 1907 and a garage in 1928. The house was named after Berea, a city in Macedonia mentioned in the Acts of the Apostles. Sweet lived at Berea House until 1928 when it was bought by James H. Rothwell, CBE, Town Clerk of Brighton, who was in residence until the 1940s. In the 1950s, outline planning permission was obtained respecting a 60-foot building plot in the gardens fronting Dyke Road Place. Following the sale in 1960, this section of the garden was cut off and Aylwin House built.

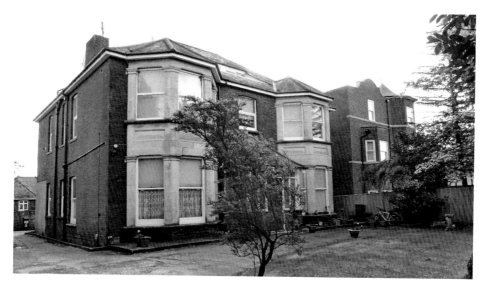

The Most Prolific Source of Wild Flowers near Brighton?

Dyke Road Copse, also known as 'Three-Cornered Copse', is a plantation dating from the early nineteenth century. It was one of the many plantings started by William Roe and his descendants on their Withdean estate. This plantation, off Dyke Road, bordered Court Farm, West Blatchington and Tongdean Farm. Over the years it gradually spread beyond the boundary fence that can be seen in both photographs. In 1934/35, Hove Corporation purchased the copse from the Curwen estate to ensure its preservation from developers. During the Second World War, its grassed area was turned into allotments. It suffered greatly at the hands of the 1987 hurricane and over new 5,000 trees were subsequently planted. It is possibly not the same Dyke Road plantation that was described by Erredge in 1862 as Brighton's most prolific source of wild flowers. That is likely to have been where the mansions Uplands, the Den and the Dyke Road Nursery later stood.

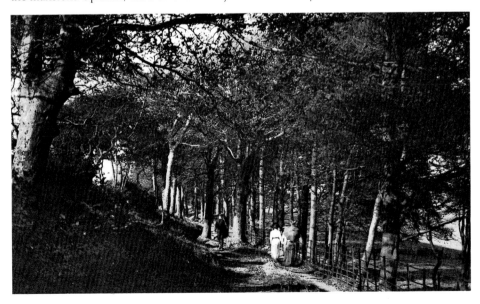

Walk 3

Wild Crescents

In 1849, Amon Henry Wild designed a huge
and innovative horseshoe-shaped crescent of
forty-eight houses for the site of the failed
pleasure gardens started by James Ireland
in 1823. The houses looked inwards over a
shared park. Brighton's Park Crescent was
not Wild's first. In 1829, he designed an
earlier scheme for Worthing, elements of
which bear comparison with Brighton's.
An important, previously unpublished,
photograph by Nicola Cassinello, who
resided at number 9 Edward Street, Grand
Parade between 1868/69, shows number
14 Park Crescent, Worthing, in 1869. That
crescent was left unfinished in 1833 as
the rough wall to the left displays. As at
Brighton, Wild employed wreaths on the
architraves but without the spaced brackets.
The photograph also shows that the doorway
of number 13 was once flanked by the same
herm atlantes as survive elsewhere there.
Numbers 24–25 in Brighton's Park Crescent
were bombed on 25 May 1943. It was almost
demolished for the new polytechnic in 1956.

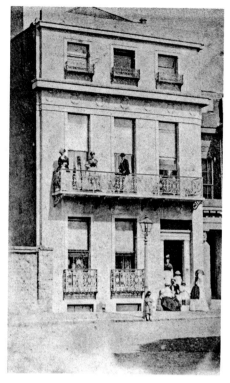

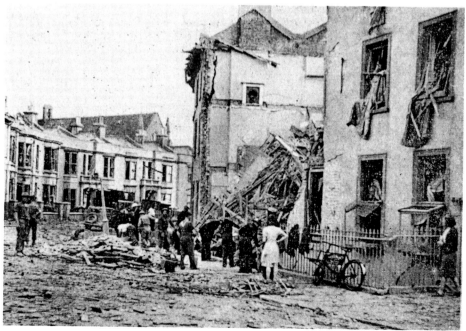

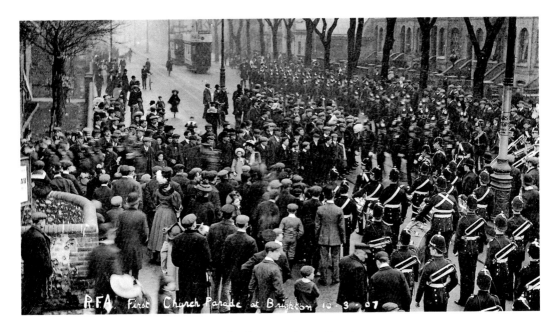

R.F.A. First Church Parade at Brighton 10-3-07

'This is the First Church Parade We Had When We Came Here'

For those thrilled by the sight of men in uniform, Sunday mornings on the Lewes Road were the cause of regular stimulation, occasioned by the church parades of the residing regiments at Preston Barracks. From the eighteenth century, the military became an everyday part of Brighton life. As the barracks were in Preston, old St Peter's had originally attempted to cater for their needs. From 1828, the new St Peter's was adopted but, in 1875, St Martin's in Lewes Road was consecrated, and its size and proximity to the barracks saw it adopted as Brighton's 'military church'. Regimental banners added to its beautiful interior. The top photograph shows the arrival of the Royal Field Artillery at St Martin's on their first church parade of 10 March 1907. Their band plays while the column wheels toward the entrance. In the lower photograph, the 20th Hussars pass Phillips & Sons Monumental Masons on their return to the barracks.

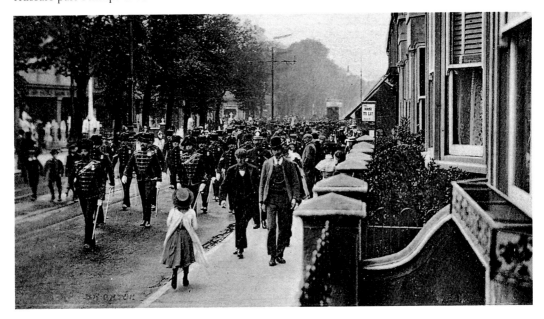

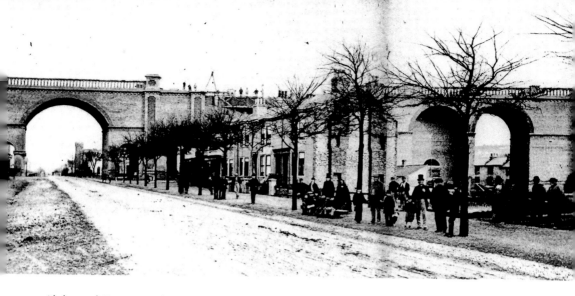

Alpha and Omega, 1869 and 1976

A panoramic photograph of 1869 formed from two exposures, showing the building of the Lewes Road viaduct, whose line to Kemp Town opened on 2 August 1869. The impressive and expensive construction curved 180 yards from Lewes Road station in D'Aubigny Road (opened 1873) across Lewes Road and then continued by a three-arched viaduct over Hartington Road. After 1933, its line only handled goods traffic until closure in 1971. Leslie Whitcomb's evocative photograph of 24 August 1976 shows the final stages of the demolition of the Lewes Road arch. The western arches remained until 1983 and the building of Sainsbury's superstore. In November 1838, Thomas Read Kemp and John Whichelo applied for a Parliamentary Bill to found a cemetery of 20 acres east of the Lewes Road but, apart from the Allen Arms at Dog Kennel Lane (Hollingdean Road), and the hillside farm called Scabe Castle, no houses existed beyond Hanover until the mid-1850s.

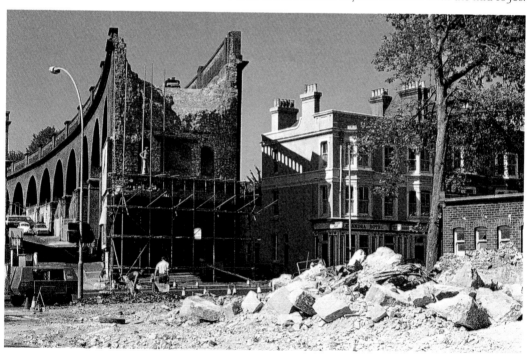

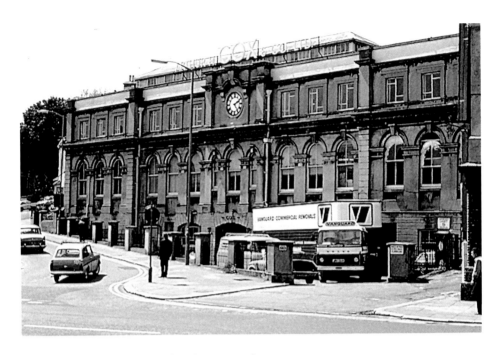

A Bitter Pill: the Last Days of Arthur H. Cox's Factory

Leslie Whitcomb's 1979 photograph of removals taking place at Cox's pill factory before its demolition in 1983. Sainsbury's superstore (opened 1985) now occupies both the factory's site and that of the adjacent Lewes Road viaduct. Arthur Hawker Cox started a chemist and druggist business at number 32 Ship Street, Brighton, in 1839. His patented 1854 invention of a pearl coating for pills brought great success and he expanded his family business throughout the century at number 10a St Martin's Place. In 1910/11, the firm moved to the impressive Brighton and Sussex Laundry building at number 93 Lewes Road. The 1860s classically inspired building had a rusticated basement and an arcaded *piano nobile*, and rather resembled the façade of an important railway terminus. The firm continued to prosper, but the 1970s plan to demolish the viaduct and redevelop the area and road system spelled disaster. In 1976 the firm moved to Whiddon Valley, Barnstaple.

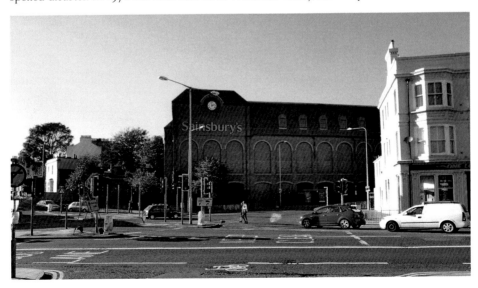

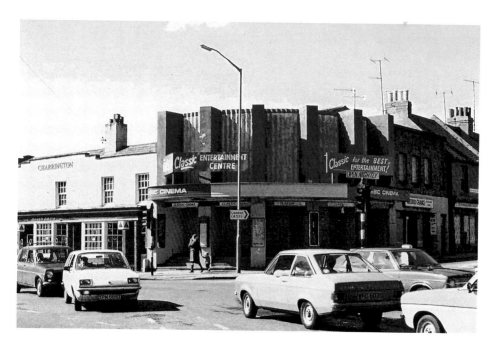

A Decided Lack of Gaiety, 23 March 1981

On 24 April 1937, Frederick W. Morgan's splendid Gaiety cinema opened on the corner of the Lewes and Hollingdean Roads. Its suburban location aimed at capturing the neighbouring areas of North Brighton. The curved façade was divided by six 50-foot, fin-like buttresses. Their curved tops rose above the ridged backing wall and all were topped and fronted with neon strips. Internally, lighting effects were employed in the dome above the staircase leading to the balcony lounge and its sofas. From 1965, the Gaiety suffered a series of name changes and uses, from bingo, via a soft porn club ('The Vogue') to cinema ('The Classic') again in 1979. Its façade, here photographed by Leslie Whitcomb, was reduced by half and ruined during this era of decline. It closed in 1980 to be replaced by the appallingly titled 'Vogue Gyratory System' that amusingly enshrines the porn club's name. Many of Hollingdean Road's modest houses were also lost then.

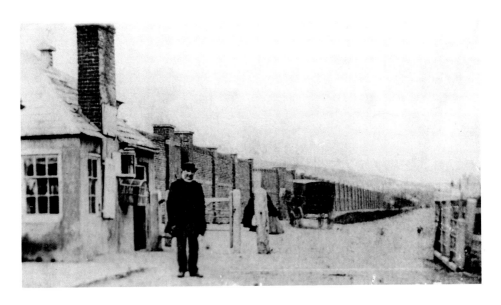

At Lewes Road Gate, 1867 and 1963

The Lewes to Brighton turnpike road was established in 1770 and there were tollhouses at Kingston and before Preston Barracks. Gone by the 1870s, the Lewes Road tollhouse flanked the road just south of the main entrance to the barracks and caught all traffic from Brighton. The guardroom lay behind it beyond the substantial boundary wall of 1818. The gate piers of the barracks' pedestrian entrance appear behind the toll collector. Beyond this a delivery van enters the south gate. In 1861 the toll collector was James Wagland, who lived at the turnpike with his wife, Mary. He died aged ninety-one in 1865, so if the photograph's date is correct, he is not the keeper shown. A wooden birdcage hangs outside the house below a lookout or lantern window. Leslie Whitcomb's April 1963 photograph looks northward from its site. The railways ruined the profits of many turnpike trusts and they were gradually wound up.

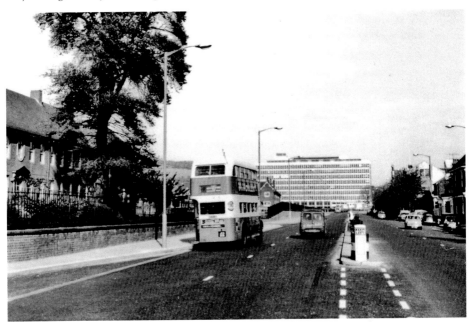

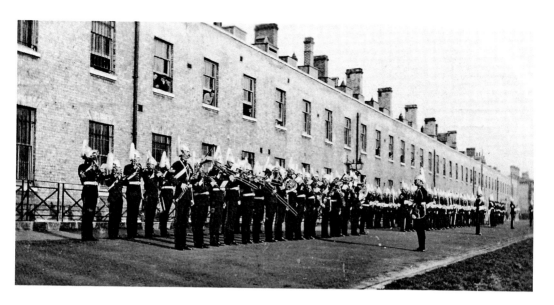

'A Handsome Pile of Yellow-Brick Buildings ... Erected 1795'

Resplendent in scarlet tunics and dark blue breeches, the 4th Royal Irish Dragoon Guards assemble for morning church parade outside the southern barrack block of Preston Cavalry Barracks in 1909. They would subsequently march to St Martin's church along the Lewes Road. Brighton had a strong military presence from the eighteenth century, with barracks in Church Street and in Preston's 'healthy valley, possessing the advantages of both air and prospect' bordering the Lewes turnpike road. Handsome barrack blocks with classically inspired, criss-cross-patterned iron balconies soon arose, together with stables, a corn store, a hospital (formerly the canteen) and all the other buildings needed for garrison life. Apart from benefiting the local economy, the constantly changing cavalry regiments added much glamour and interest to Brighton's social scene. Brightonians enjoyed regimental sporting fixtures, including polo and rugby, and the jollity of military bands. Brighton's close involvement with the military is now largely forgotten.

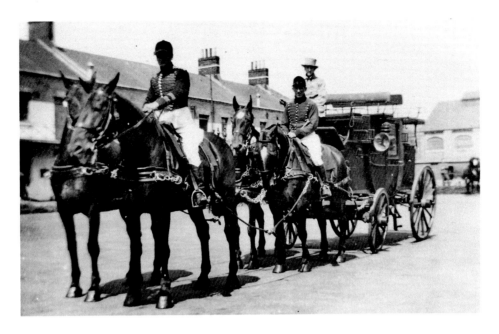

Jubilee Day at Preston Barracks, 6 May 1935

Despite being a weekly sight en route to Preston Park for polo, the 1930s saw modernity gradually replace many of the horses at Preston Barracks. The military played a great part in local celebrations and held their own tattoos at the barracks. Here, on the parade ground, a mail coach with postilions awaits suitably costumed passengers to take part in a parade to celebrate George V's Silver Jubilee. The northern barracks appears behind. Brighton celebrated the Jubilee between 6–11 May and local scouts built a huge beacon bonfire at Hollingbury 'Roman' Camp. Preston Barracks' importance gradually waned and closure threatened, but £250,000 was spent on reconstruction in 1938and it survived until the 1980s when Brighton Council acquired it. Regardless of the Barracks' architectural and historical importance and in an act of complete philistinism, all but the 1793 canteen/hospital and the 1930s officers' mess was demolished for a retail park. In 2014 much of the site remains derelict.

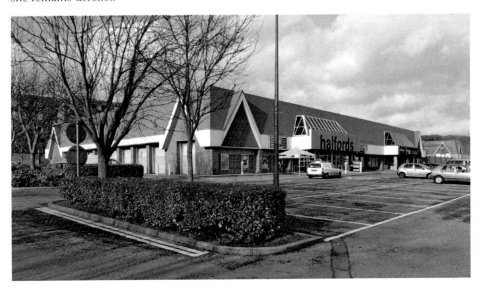

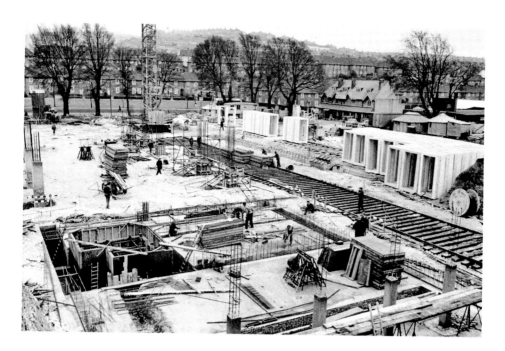

'The Most Important Planning Decision Since the War'

In May 1956, Brighton Council announced plans to build a College of Advanced Technology costing up to £1 million on the site of the Moulsecoomb playing fields. This was not good news for the estate and the Community Association protested. However, it was an architectural blessing for Brighton as many councillors, including Lewis Cohen and Cllr R. Bates (Chairman of the Planning Committee), favoured a central location and the compulsory purchase and demolition of Park Crescent and the displacement of 110 families as an alternative. Bates pointed out that the council would be under no obligation to rehouse them. Compulsory purchase would have cost £60,000 extra and this largely saved the Crescent. Stanmer was another rejected location. Donald Trezise's photograph was taken on 30 March 1961 and shows architect Percy Billington's College of Technology under construction. Beyond the stacked concrete window frames may be seen the early twentieth-century Moulsecoomb Villas, now lost beneath a car park.

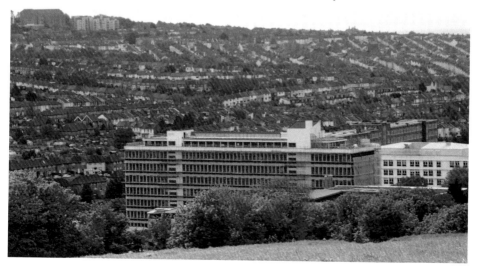

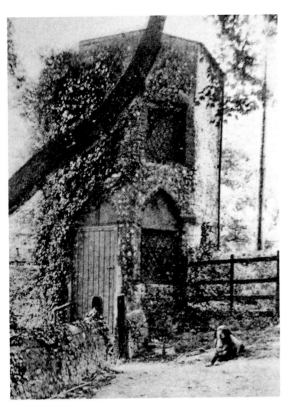

A Princely Retreat at Moulsecoomb Place

On high ground west of the manor and next to the railway stood an octagonal sixteenth- to seventeenth-century tower known colloquially as 'the Prince's Bower' on account of the Prince Regent having used it as a retreat during his frequent visits to Moulsecoomb Place. The upper floor was reached by a ladder and above was a dovecote that externally appears to have been of later construction. Probably in the eighteenth century, the building became a 'bower' or garden house. Originally it had a three-pointed entrance and window arches on the eastern sides. Around 1920, Henry Edmunds commissioned alterations, turning both of the windows (*seen in the upper photograph*) into doors while blocking the original entrance with an external staircase. The 1925 photograph shows the southern façades. In the late 1920s, Moulsecoomb Place was bought by Brighton Corporation. The Bower suffered the fate of many outbuildings in Britain when mansions are council owned, and was demolished as an inexpensive solution following vandalism in 1942.

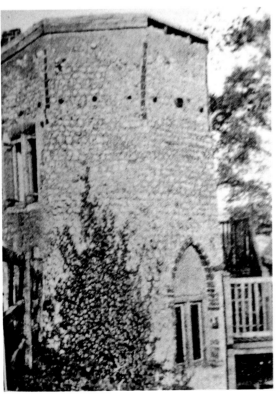

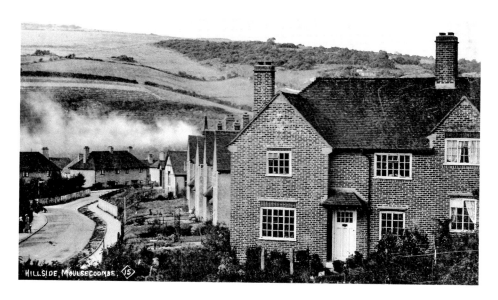

'A Hamlet in Patcham on the Road to Lewes'

Few Brightonians would imagine that Moulsecoomb was once part of Patcham. The peculiarities of the parish boundaries along the Lewes Road meant that within a few hundred yards one travelled across the borders of Brighton, Preston and Patcham. Brighton extended its boundaries in 1923 to include it. South Moulsecoomb's Hillside is here photographed around 1930. The new estate's architecture, like Bristol's coeval Sea Mills Park, was Neo-Georgian cottage style. Much of the cottages' visual charm originated in the Georgian style glazing and matching front doors, which is evident when replaced by modern styles. Even shop windows on the estate had Georgian glazing. The half-timbered façade of the first St Andrew's church appears below the smoke. It was replaced in masonry in 1934. A nursery, open fields and Hollingbury Barn appear on the distant hillside, displaying why the new estate was considered more rural than suburban. The composer William Havergal Brian lived at number 130 Hillside between 1922 and 1927.

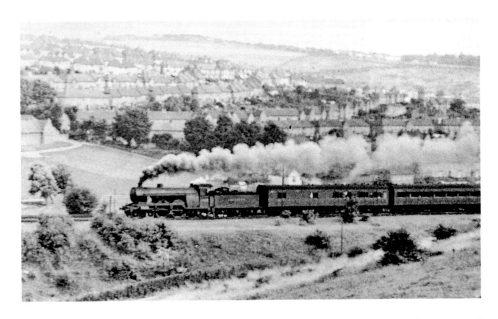

'A Very Short Ride Behind the Iron Horse Brings Visitors to Several Charming Retreats'
Trees now obscure this view taken in the early 1950s. An Atlantic locomotive approaches
Hodshrove viaduct on the Brighton to Lewes line, passing Moulsecoomb on its way
to Falmer, Lewes and beyond. The establishment of the railway lines to Brighton by
1847 afforded visitors and locals the opportunity of day trips to more historic or sylvan
locations. As a pre-school child in Preston, a great delight on afternoon walks was to
stand on London Road station's passenger bridge and to watch and be enveloped in smoke
and steam as trains chuffed by beneath. Beyond the engine at the left, and above its
spacious lawns, appears one of the buildings of Moulsecoomb school, opened in 1929/30.
The houses of East Moulsecoomb appear high on the hill behind it. The older buildings of
South Moulsecoomb, with their bosky open spaces and gardens, spread across the picture
to the right of the school. Bevendean appears high on its distant hill behind.

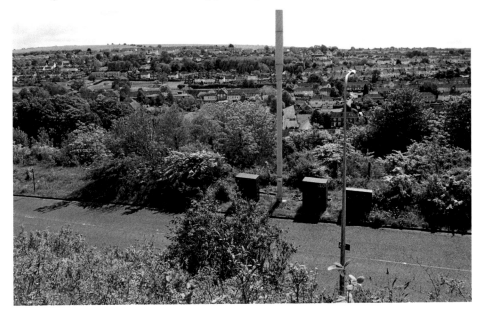

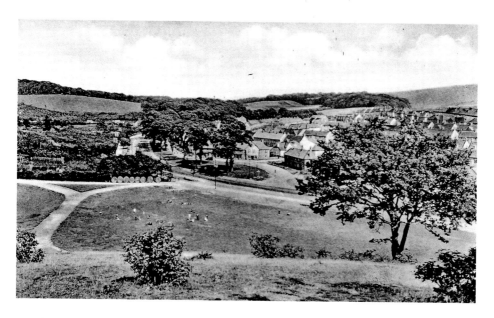

North Moulsecoomb from the Wild Park, 1931

A view to Barcombe Road across the Lewes Road before woodland covered the park's bare slopes. Beyond Newick Road's turning, the houses of Chailey Road and Ringmer Drive cover the slopes. Before Lewes Road was widened, there was a lunette-shaped island before the shops of Barcombe Road and thus direct access to the main route. North Moulsecoomb estate was designed by Professor Stanley Davenport Adshead and its 390 homes rose between 1926 and 1930. The greater density of houses on this new estate, and its minimal amenities, led to the building of St George's Hall, a chapel of ease that also could be hired for community events. At the left of the photograph appears the path to the sports ground, photographed below by Leslie Witcomb in 1989. Woollard's nursery spreads along Lewes road to Coldean's cottages below 'Mr West's Field' and Stanmer Woods. In 1955, the nursery was turned into an award-winning ornamental area called the Parkway.

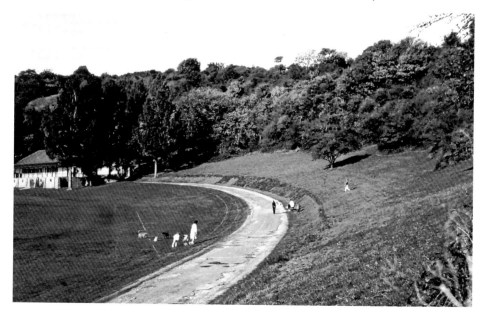

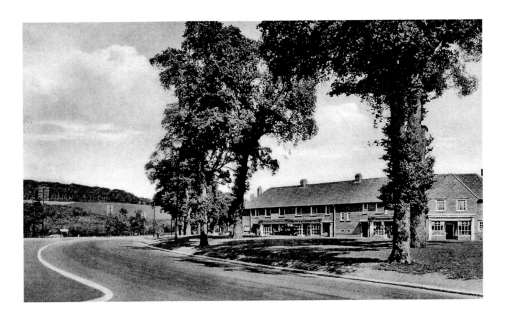

At the Shops, 1932

Although North Moulsecoomb had few amenities, it did possess an attractive parade of double-fronted shops in Barcombe Road to meet the new settlers' daily requirements. These, like the rest of the estate, were Neo-Georgian cottage style in spirit, with the shop windows enlivened and divided by small panes and white glazing bars. Visually, they compared favourably with today's modernised façades. On the right of the photograph at number 49 is Frederick Sandalls, the grocer's. At number 48 is Horace Davis, the chemist's, at number 47, Frederick Leaney, the butcher's, and number 46 is Harry Weller's newsagent and post office. The combined surgeries of Dr Frederick Webb and Harold Jenner, dentist, could be found at number 45. Stanmer Park's wonderful cathedral of beech trees that would fall before the 1987 hurricane then still sublimely crested the hill beyond.

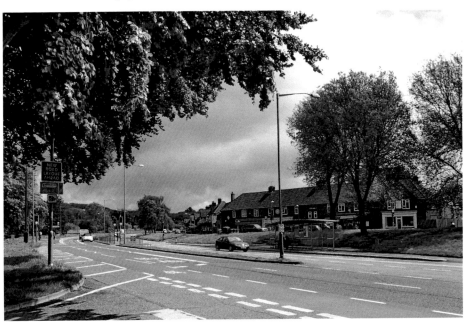

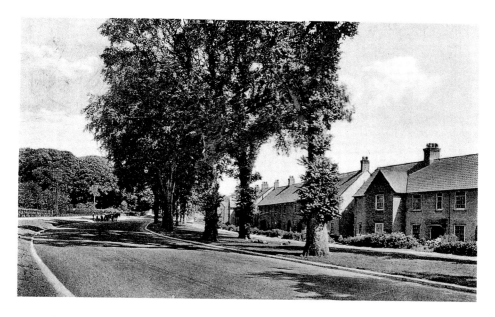

A Rural Idyll

On a summer day in 1933, workmen in shirtsleeves and waistcoats attend to curbing stones on the Lewes Road. On the left may be seen the perimeter fence of Frank and Gordon Woollard's nursery that was noted for its delicious fruit, as local children discovered during occasional raids. The garden wall of Coldean cottages appears in the distance, at the corner of Coldean Lane. In marked contrast to today, the road is both narrower and devoid of traffic. On the right, the recently built cottages of the North Moulsecoomb estate are fronted by Barcombe Road. Children sit on the grass separating the two roads that somewhat removed the inhabitants from the noise and danger of a major route. This grass then still bore the magnificent and long-lost trees that had bordered the original Lewes Road. For tenants used to the grime and density of inner-city housing, the change to rurality must have been remarkable.

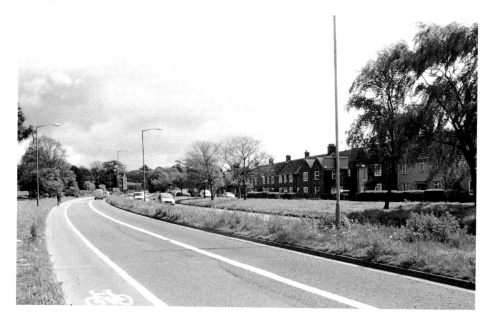

Cold Dean from Moulse Coomb Pit, 1914

The few farmworkers' cottages comprising the then hamlet, of Cold Dean at the confluence of Cold Dean Lane, with the Lewes Road appearing distantly in this view. In the left foreground, at the foot of the copse, may be seen the kite-shaped enclosure or hedged field that appears on maps from Edwardian times. It is now part of the sports ground and park entrance. In 1954, Coldean Lane was widened in its entirety. Alas, all of the hamlet's original cottages, including the Georgian Menagerie Cottage (Coldean Farm), where the Pelhams of Stanmer House had kept their dogs and other animals, were demolished both for this and also, by the early 1960s, for the development of Woburn Place. Only the menagerie's barn survived to be converted into the church of St Mary Magdalene in 1955. In the large field beyond, Mr West's cattle grazed in the 1950s. I squeamishly knew it as 'The Field of Pancakes'.

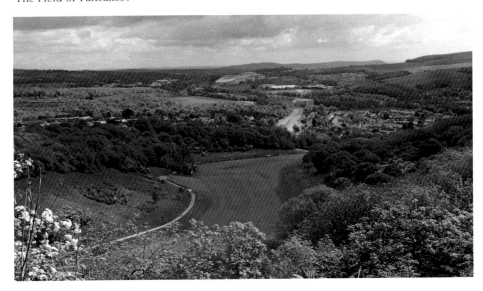

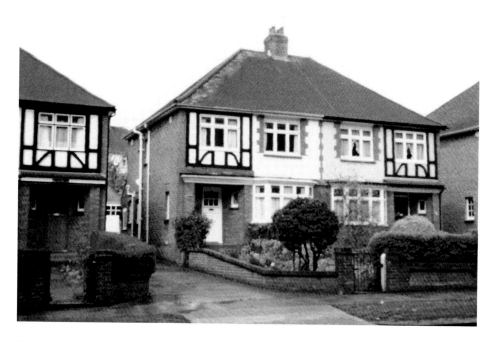

'Aunty Joan's House', Number 15 Coldean Lane

Until the 1930s, narrow and rural Coldean Lane served only a few cottages at the junction to Lewes Road and the hillside farm. In 1935, Charles W. Munday submitted plans for twenty-eight houses on the lane to be called Parkside Estate. G. W. Warr likewise submitted plans for eight shops, four garages and more houses. Notwithstanding it being in Falmer and Stanmer parishes, the lane first features in Brighton's 1936 directory under North Moulsecoomb, although beyond the borough boundaries until 1952. By 1938, eighteen new properties along the lane were occupied. As a result of these developments, part of the lane was widened during 1937/38. Semi-detached and Tudoresque, 14–16 Coldean Lane (photographed in 1979) are some of Parkside's first houses. They shared drives, which sometimes caused problems once cars became universally owned. Albert West, who farmed fields within Stanmer Park and the surrounding area, was my aunt's neighbour and lived at number 14 (on the left) from 1957–72.

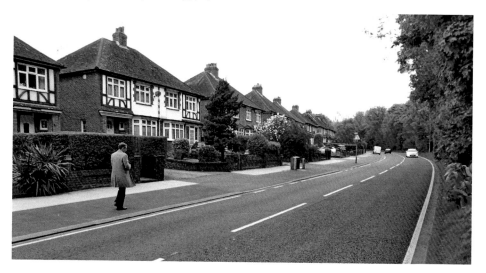

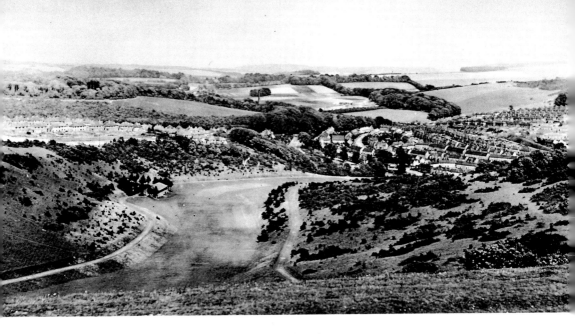

Coldean and North Moulsecoomb from the Wild Park, 1954

Coldean estate, on the left and seen across Moulsecoomb Pit from below Hollinbury Iron Age hill fort, was under construction in the early 1950s. Hollingbury barn and dewpond lay to its south-east. Land between the Wild Park and Coldean Lane was bought from Kemptown Brewery in 1937 and was developed by the council from the 1950s. North Moulsecoomb appears to the right, and beyond it is a landscape yet untroubled by today's highway, educational or sporting requirements. The Wild Park was acquired in 1925 as part of the Moulsecoomb Place estate. The sports ground in the Pit with its pavilion was in existence by 1932. Numbers 15–21 Ingham Drive, seen below when new in 1953, were typical of the modern cottage-style homes on the attractive hillside council estate. In 1954, the council owned 9,500 properties housing 38,000 people. The number of Brightonians on the Housing Department's waiting list was 4,719. It had reached a peak of 6,519 in 1947.

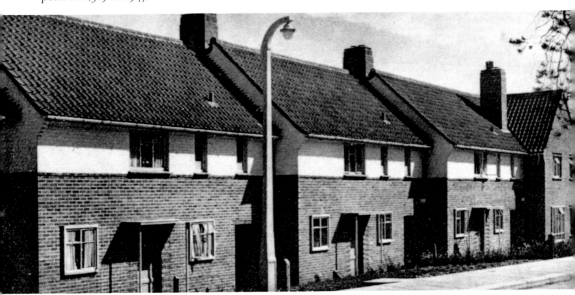

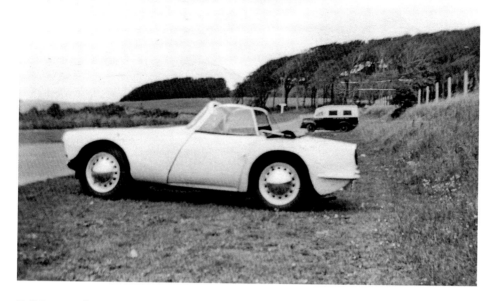

Full Steam Ahead! 1965

The Claydon steam car on Ditchling Road, near Old Boat Corner. Its inventor, Horace Bruce Claydon, was a schoolmaster's son and brought up at number 43 Miller's Road, Preston. A professional horologist, he had always been passionate about engines. As a boy, he constructed railway signals in his garden beside the railway and drivers would sound their whistles in recognition. After 1940, the family moved to Coldean Lane. In 1948, he designed and built a car in frustration at being unable to purchase one due to post-war austerity. A 1949 Pathé news film story survives showing this first midget car, ingeniously built around a 2½ hp motorcycle engine. By the 1950s, he was building steam cars. He married my aunt, Joan Beeson, in 1953. His cars went into American and British private collections. A shepherd's hut made from an upturned boat orginially named the corner. The A27 now slices through the hillside before traversing Stanmer's once tranquil fields.

Walk 4

Ditchling Road and the Level, 1930

The view to the Level, the Lewes Road and the hillside beyond. Oxford Street is on the left, Oxford Place on the right, and the rear façades of Ditchling Road (before 1901, Brunswick Place North) appear before the trees. The tall, pedimented building is the 1830s hostelry The Brunswick Arms. Behind it, and to the viewer's left, is the row of eight cottages called Brunswick Court that were approached via a passage next to number 25, Oxford Street. The complexity of this area between London Road and Ditchling Road is evident. By the 1870s, as well as the cottages of Brunswick and Oxford Courts, it also accommodated two slaughter houses. Apart from some cottages at the east end of Oxford Street and some of the Ditchling Road buildings, everything else has fallen before the monolithic and sterile rebuilding programmes of recent decades. The lower view shows The Brunswick Arms and neighbouring properties from the Level in 1906.

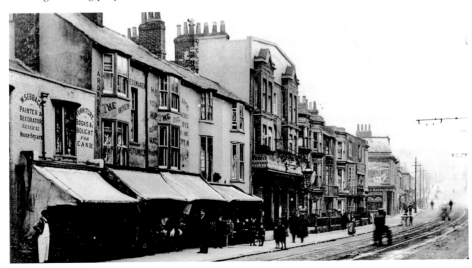

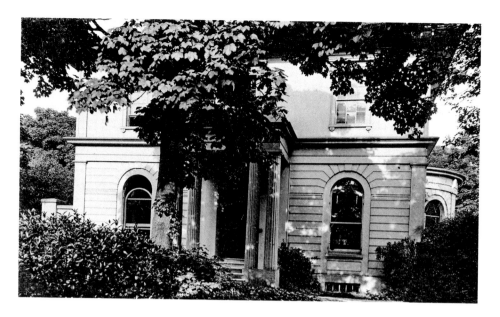

Rose Hill Villa, Ditchling Road

The fine, 1820s Italianate Rose Hill Villa stood above the junction of Ditchling Road and Gipsy Lane (also called Old Shoreham Road and now Upper Lewes Road). Its builder John Colbatch, clerk to the magistrates, surrounded its extensive gardens with a wall that was originally 15 feet high in sections. The subsequent erection of William Stanford's wall opposite dangerously constricted Ditchling Road. The villa boasted a western Doric portico and a central southern bow. Colbatch enclosed a pond within his grounds, beside which lived the Trafalgar veteran and Brighton 'character' Cpl Staines, who then moved beyond the walls. By the 1830s, Colbatch inserted his grand Rosehill Cottage beside the drained pond, replacing another structure. By the 1860s, Colbatch's family had added two adjacent villas. Around 1893, Rose Hill Villa was renamed Hill Lodge and in 1908 became an annexe of the Diocesan Training College. Compulsorily purchased for public housing in 1947, it was later demolished.

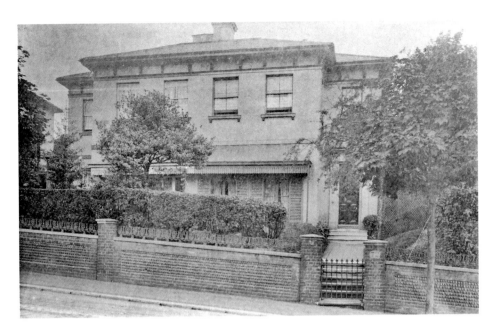

'Been so Busy': Mrs Waterman Entertains

Numbers 72–74 Ditchling Road, as they were around 1912 when they were the residence of Mrs M. A. Waterman and H. J. Smith. Previously called Yverdun House and Cleveland House, the properties were two of eight substantial, semi-detached Italianate villas that rose between 1854/55 in a small development called Round Hill Park. Raised above road level and enjoying superb views, they were originally backed by substantial ornamental gardens. Cleveland's stretched in an L shape to Prince's Crescent, whereas Yverdun's looped around to the south. The beach-pebble and brick front-garden walls were topped by low cast-iron panels in a vegetal design. As all of the houses faced west, their front reception rooms were heavily protected from the annoying effects of the late afternoon and evening sun by fringed canopied verandas and louvred shutters. A later fashion for light and sunshine has seen sections of the lead canopies replaced in glass. Others have been totally lost to decay.

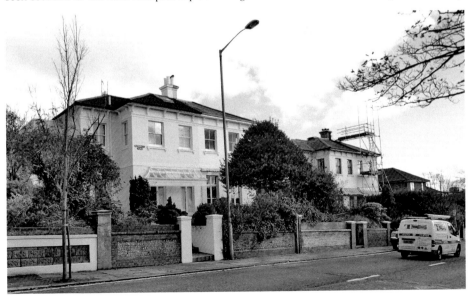

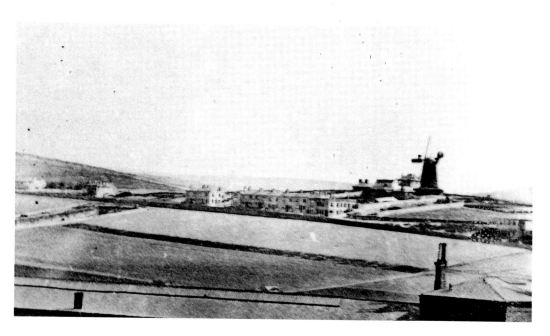

Ditchling Road and Round Hill, 1870 and 1930

Round Hill and the Ditchling Road, seen above Preston fields, yet untroubled by development. Far left appears the railway tunnel below Ditchling Road. The shaded side of the 7-foot-high wall along the western side of Ditchling Road, denoting the limits of Stanford land, crosses the photograph. The building of this wall narrowed the road above Rose Hill Cottage so greatly that carts could scarcely pass abreast between the equally high parallel walls, and pedestrians were trapped and endangered. It caused a Mr Richardson to indict William Stanford in 1838 for building on the turnpike road. Tower Windmill dominates the hillside, with Prince's Villa behind to its left. Far left appear Warleigh Lodge and Round Hill House. Either side of Prince's Road and towards Princes Crescent appears Ranelagh Terrace (1859/60) with the Duke of Edinburgh (renamed the Round Hill Tavern from 1876). The first houses of Round Hill Park (built 1856) appear far right.

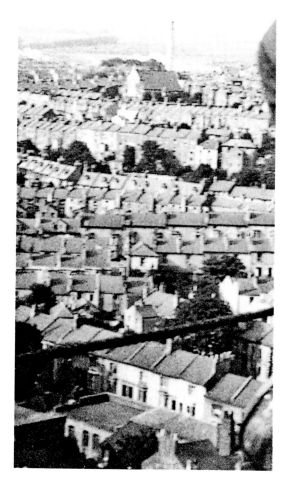

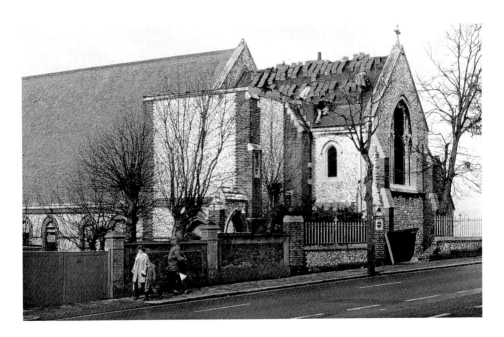

The Last Days of St Saviour's, February 1983

Leslie Whitcomb's photograph of the demolition of Edmund Scott and F. T. Cawthorn's 1886 church on Ditchling Road. Built of flint rubble with brick dressings, the church dominated Preston's eastern skyline. Terraced into the hillside, it had a hall beneath the nave that was much used by schools in the Second World War. It possessed aisles, north and south porches and a vestry at the north-east. The chancel was consecrated in 1900. A planned tower with a broach spire remained a stump at the south-east corner, rendering the church visually unimpressive from Ditchling Road. Inside was a huge reredos designed in 1867 for Chichester Cathedral by Richard Herbert Carpenter and sculpted by James Forsyth. Installed in the 1900s, it was saved for the redundant church of All Saints, Portfield, Chichester in 1983. A rescued stained-glass window was also installed in St Augustine's in 1987. A western gateway to the church survives in Vere Road.

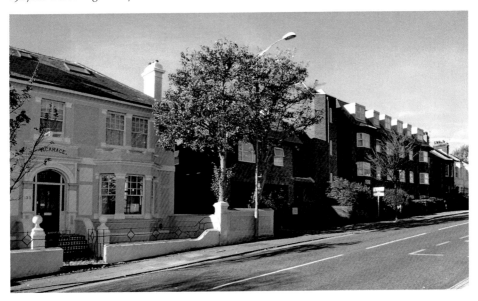

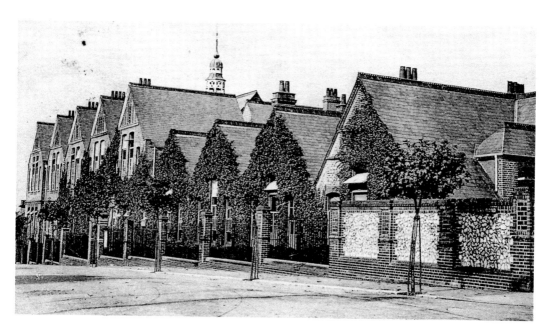

From Ditchling Road to the Downs

In 1890, land north of Rugby Road was acquired by the Brighton and Preston School Board from the Stanford Estate as a site for the Ditchling Road Schools. The official opening date of 3 October 1890 seems remarkably early, as Thomas Simpson's architectural plans had only been submitted in February. The premises do not feature in directories until the edition of 1895 that first mentions Ditchling Rise School, but by 1896 proclaims Ditchling Road Board Schools. It was run by a triumvirate of principals and catered for boys, girls and mixed infants. By 1947 it had changed its name to the Downs County Primary School, a name previously used by the Downs private girls' school at numbers 183–185 Preston Road. The 1936 photograph shows silken-clad prizewinners, perhaps from school athletics. Young Bill Sladen holds his tennis racquet prize while others display handbags, cases, alarm clocks and pocket watches. Numbers 51–55 Grantham Road close the scene.

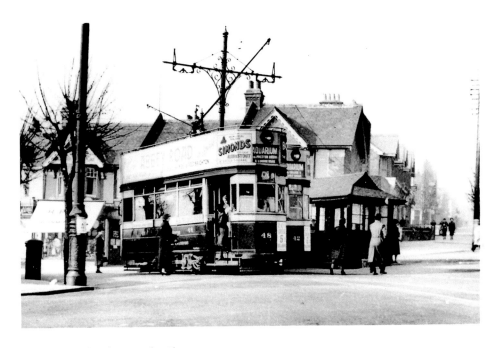

Comings and Goings at the Fiveways

Passengers alight and others board trams numbered 48 and 42 at the Fiveways in the late 1930s, prior to the cessation of the entire service in 1939. One of the trellis-clad, rustic passenger shelters sits in the centre of the road. Originally, two routes crossed at the junction now known as the Fiveways. These were the (Preston) Drove and the Ditchling turnpike road. Another lane following approximately the route of the 1903/04 Hollingbury Terrace from Harrington Farm joined them. From 1881, Stanford Avenue reached up to this crossroads and Hollingbury Road joined the ensemble in 1905. When the colloquially used name 'Fiveways' was coined is problematic. It was certainly old when the author was a child in the 1950s, but it obviously cannot predate 1905 and probably belongs to the teens or 1920s. It is not listed in directories, and local shops up to 1973 seem not to have included it in their names.

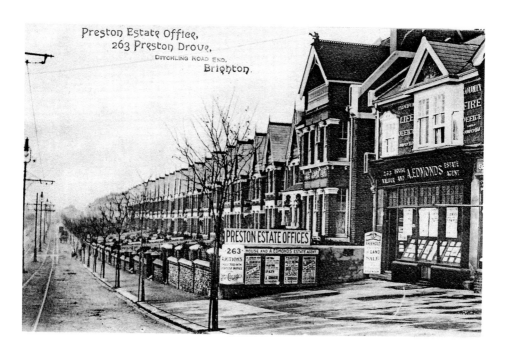

Preston Estate Office,
263 Preston Drove,
DITCHLING ROAD END,
Brighton.

'Re Boundary House ... Kindly Let Me Have a Reply to My Letter'

Thus did an exasperated Mr Edmonds write to Mrs Miles in Kent on 12 August 1908, regarding the property occupying the site of the tollhouse in Ditchling Road. His agency was at number 263, Preston Drove, adjoining a house displaying a splendid dragon gable finial. The changing array of shops at Ditchling Road and Preston Drove provided all of life's necessities and catered for a large, mostly middle-class, community. They formed a close-knit group of traders. Greengrocer Bill Sladen's daughter, Hazel Smith, recalls her pleasant childhood in the area in the 1950s and 1960s: 'It was a lovely community at Fiveways when I was growing up, with "the Bacons" in the hardware shop, "the Dorringtons in the newsagents, "the Toogoods" in the fish and chip shop, "the Lawrence's" in the butcher's, "the Pickles" in the chemist's and "the Eastwoods" in their garden centre.' The 1923 image shows that number 263 had by then become Taylor's furniture dealers.

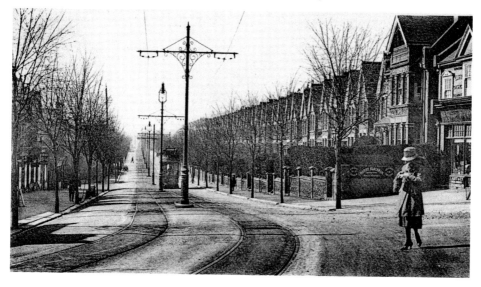

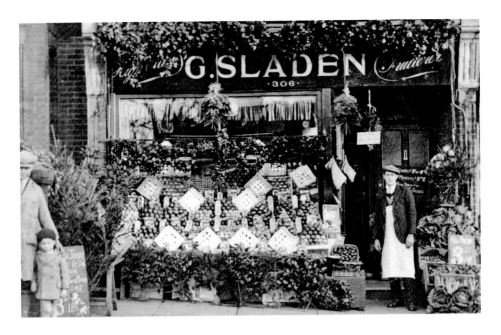

Christmas and the High Class Fruiterer, 1931

George Sladen stands by the shop scales outside his greengrocer's shop at number 306 Ditchling Road. The window sports a Christmas frill of crêpe paper, and wreaths obfuscate the shop's fascia and hang from a wooden stand. Small Christmas trees jostle with holly along the front of the orange, date and fig-laden stand and hang from the façade, hinting at their popularity as table decorations. Larger trees back assistant Charlie Hatchard and George's little son Bill, who would take over the business on his father's death. The shop has been a greengrocer's since 1913 and still continues the tradition in 2014. George took over the business in 1929, having moved from Enfield. Young Bill and his wife Ivy continued working together with George until the latter felt unable to continue. Bill Sladen sold it on his retirement in April 1983.

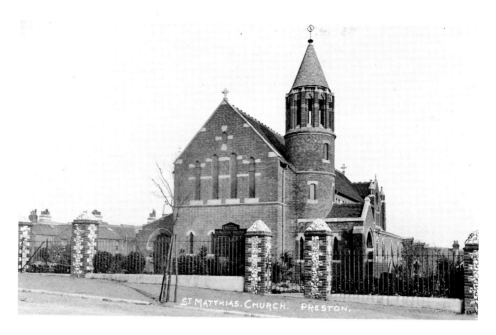

St Matthias Church. Preston.

Mr Ridge's Singular Edifice, St Matthias, Preston Park

In 1901, a prefabricated iron church was erected to cater for Ditchling Road's fast growing community on land offered by Mr C. W. Catt opposite the brickworks between Dover and Ashford Roads. This soon proved inadequate and, in December 1906, the foundation stone for the present building was laid. It was designed by the London-based Lacy William Ridge (1839–1922), who was also the Chichester Diocesan surveyor and architect. The chancel was dedicated in July 1907. An extension was added in 1910 and the finished church consecrated on 11 January 1912. Ridge's ambitious brick and freestone church clings to the hillside, the gradient allowing a parish room to be built below the chancel overlooking Hollingbury Park Avenue. The aisled building, with its memorable circular bell tower, is Early English in inspiration and its brick is enhanced by stone architectural details. The attractive interior included fine carpentry, stained glass and a font from St John Meads, Eastbourne.

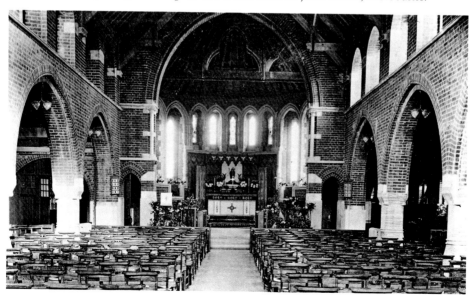

Our Gang, Just Doing Our Bit!

Outside number 313 Ditchling Road in 1915, a child peers from the window as a determined band of female war workers pose with their foreman and an elderly labourer before a Brighton Corporation steamroller. The photograph was taken by A. K. Pink of neighbouring number 29 Dover Road. The number of women employed rose dramatically during the First World War and this gang were presumably bound for roadworks in the expanding area. At the time, Brighton roads were constructed of rolled flint spread over a chalk base with an infilling mixture of gravel and water and then consolidated with a heavy roller. This was said to give a good grip to horses' hooves. On steep hills, however, the horse-drawn vehicles would zigzag, resulting in damage to the surface and the chalk becoming white mud in wet weather and dust in dry. In the late 1920s, tarmacadam started to be used in earnest on Brighton roads.

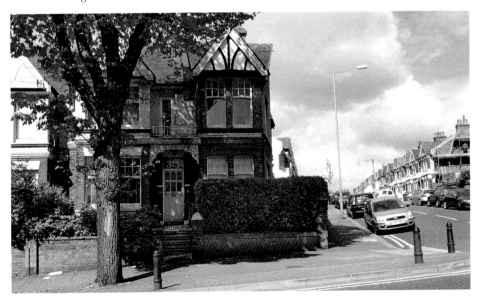

Up the Garden Path

For Christmas 1924, Mr and Mrs H. W. Cooper of number 19 Dover Road decided to send their friends 'cheery Christmas greetings' on a specially designed Yuletide postcard with four postage-stamp-sized photographic views of the house and three figures in the back garden. Dover Road first appears in directories in 1901, but without houses. Twelve had been built by 1905 and the full complement by around 1911, after which they were properly numbered. number 19 had a succession of tenants before 1924, and was listed as the home of William Ernest Stevens from 1920 to 1927, with H. W. Cooper (presumably a relative) only listed in 1928. Mrs Cooper stands before a bicycle shed at the end of a fruit-tree-filled garden. The undulating and winding gravel path follows the contours of the ground. House backs in Osborne Road close the scene. Dover, Ashford, Sandgate and Hythe Roads form a Kentish triangle off the Ditchling Road.

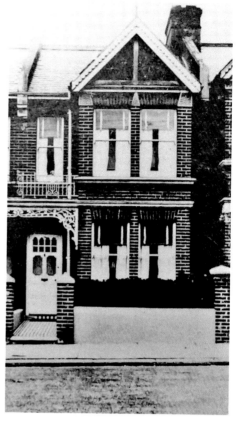

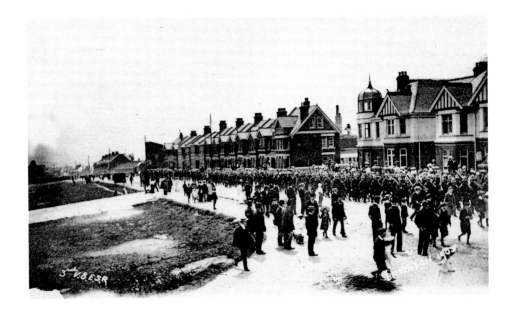

Marching to Hollingbury Camp, 1905

From Brighton's boundary, which only a decade before bore a turnpike, the photographer captures the 3rd Volunteer Battalion East Surrey Regiment returning to Hollingbury Camp. The photograph illustrates just how far the new Preston estates had expanded up Ditchling Road. The handsome group of houses on the right includes Tower House on the corner of Osborne Road. None are yet tenanted and windows bear posters advertising their desirability. Resembling houses from Preston Drove, Rothesay, on the opposite corner of Osborne Road, boasts a veranda and a rear conservatory. Beyond its attached terrace, the low buildings of the Patent Ironstone brickworks (previously J. T. Sheppard's) appear between Dover and Ashford Roads. Presumably, these provided the vast number of bricks required for Preston's expansion. They had gone by 1909 and were replaced with houses by 1912, necessitating the renumbering of existing properties. Beyond the white scar of Hollingbury Rise on the left, the iron predecessor to St Matthias church distantly appears.

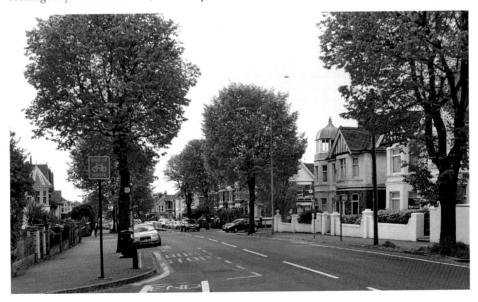

Claiming 'the Nimble Sixpence from all Wheeled Vehicles'

'They were necessary but exasperating evils, and no one but the artist regrets their disappearance', wrote Arthur Cooke of Brighton's turnpikes. Walter Puttick recorded Ditchling Road's long defunct Hill Gate turnpike, from the south-east in 1892, before its demolition. The tollhouse adjoined the Preston and Patcham parish border and was replaced by Boundary House. Number 353 Ditchling Road (the modern slate-roofed, double-gabled house seen below) now stands on the site. In 1838, objections were raised by a young man named Richardson, to the positioning of the turnpike near Brighton's boundary. He quoted an Act of Parliament, stating that no tollhouse should be within a mile of the town. He advised a public meeting of his readiness to join in a demolition party. By 1905, new houses had spread north to cover its precincts. From 1912, Mrs Gough briefly opened tearooms for intrepid explorers to Hollingbury Camp in Tower House on the corner of Osborne Road.

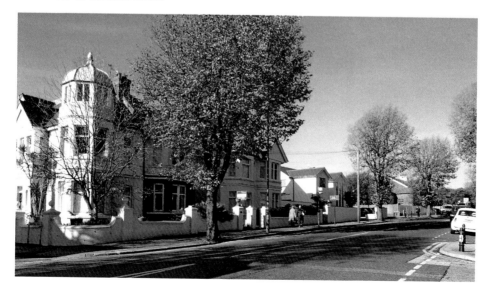

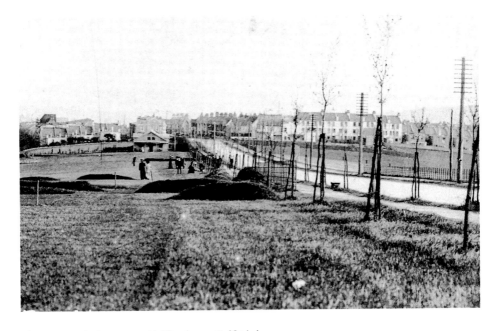

The Outer Limits, 1909: Hollingbury Golf Links

In September 1908, the Mayor of Brighton opened the municipal golf links at Hollingbury. This covered around 240 acres, with the first two holes running alongside the newly tree-lined Ditchling Road. The Golf House, seen beyond the figures, was a wooden building situated close to the roadside where the present Play House nursery stands. In later years, it and its successor became a bowls and tennis clubhouse. Beyond appear the northern limits of Preston, with the first houses of Osborne Road on the right and the roofs of completed neighbouring roads beyond. Hollingbury Park Avenue appears on the left with the dark bulk of St Matthias church, then under construction, beyond. The second photograph also looks south, featuring the links with the Dust Destructor chimney beyond and Round Hill windmill to its right. The adjacent early-nineteenth-century woods were decimated by the 1987 hurricane. The new links banished future military encampments to Patcham's downland.

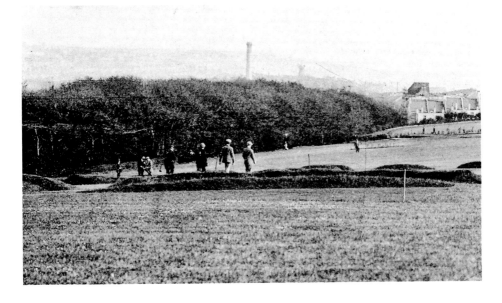

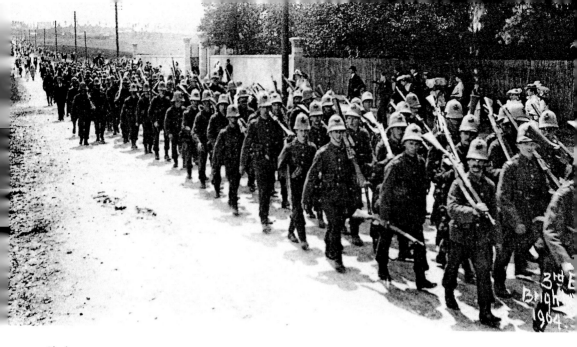

Shakespearean Treasures and a Regiment at Ease.

One afternoon in 1904, the 3rd Volunteer Battalion East Surrey Regiment passes Hollingbury Copse's main gateway opposite to the tents of their adjacent camp. Their informal marching style suggests that they are about to break muster. Hollingbury Copse was the residence of Shakespearean scholar James Halliwell-Phillipps (1820–89) and a treasure trove of rarities. In 1877/78 he purchased 14 acres called Hollingbury Copse in Patcham. His projected mansion never materialised and he erected a singular 'temporary' wooden bungalow covered in sheet iron instead. He died in 1889 and was buried at Patcham. In the 1890s, German-born, naturalised Briton Sigismund Charles Witting, a bachelor metal merchant, replaced it with a gothic mansion. Sold in 1926, it became Hollingbury Court School. Witting died in Monaco in 1933. Once a notable feature in the downland landscape for its thick plantations (*here photographed in 1911*), houses gradually replaced them from the late 1930s and Hollingbury Copse itself was demolished in 1961.

'Hollingbury Camp, 1926 ... Full Circle'

Watched by golfers and a motorcyclist, a Brighton Hove and Sussex Grammar School 'six-former' proffers a bone to the archaeologist discussing a skull with Thomas Read, the school's benefactor. Louis Ginnett's 1939 painting completed *The Story of Man in Sussex*, his great sixteen-year project for the School's assembly hall. This was accomplished in nine great canvases and forms one of the most important decorative schemes for a building in Britain. Ginnett (1875–1946), a former pupil, was one of the artists who colonised Ditchling in the 1920s. In a letter in the author's collection, he writes of the praise fellow artists Frank Brangwyn and Glyn Philpot had heaped on this work. Although the excavation is imaginary, one did take place close by in 1908. Ginnett's models were mostly school personnel and appear in several of the panels. Leslie Whitcomb's 1930s picture of Hollingbury's nearby tennis courts looks northward towards the 'Roman camp's' distant earthworks.